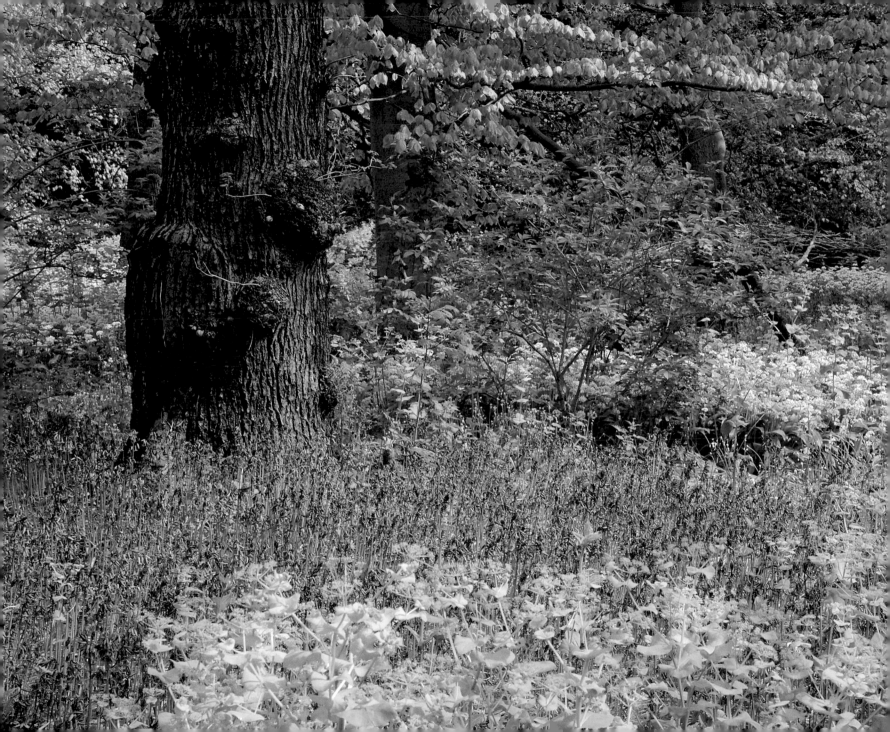

SPRING

As the dormant winter mantle is shed, the spring cloak gradually develops a wonderful kaleidoscope of colours. Also, at this time of year, early in the day the air is filled with a cacophony of bird song.

After the short winter days, the amount of daylight gradually increases; this together with increasing temperatures is the trigger for buds to burst. Deciduous trees which stood gaunt through winter begin to flush out in ephemeral shades of pale green (hornbeam *Carpinus betulus* and beech *Fagus sylvatica*), acid yellow (common oak *Quercus robur*) or bronze (walnut *Juglans regia*); changing all too soon to a dull green that persists until the autumn. Common ash (*Fraxinus excelsior*) buds, which are almost black, open to reveal the branching flower stems before the leaves, whereas beech and sweet chestnut (*Castanea sativa*) unfurl their neatly folded leaves just before the flowers appear.

Spring is also the season of great activity within the natural world. This is an especially busy time for birds as they build new nests or repair old ones prior to egg laying. Many can be seen gathering twigs, leaves or the occasional feather. Freshly open flowers are an invitation to bees, hoverflies and butterflies to forage for nectar or pollen, thereby unwittingly picking up pollen on their bodies and transferring it to the next flower they visit.

Annual records of the date when a particular plant comes into flower, a butterfly is first seen on the wing, bud burst on a tree or frogs spawn in the same location are invaluable for seeing a trend for the onset of spring. The study of the timing of recurring natural events is known as phenology. There has been a great upsurge of interest in

left

A floral carpet in the Conservation Area: bluebells (*Hyacinthoides non-scripta*) with perfoliate alexanders (*Smyrnium perfoliatum*) and wild garlic (*Allium ursinum*). 2 May 2008

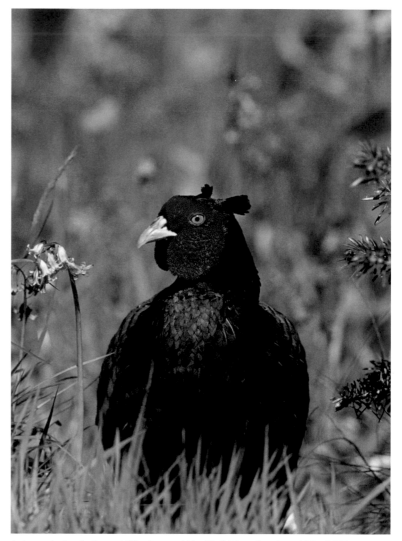

A ring-necked cock pheasant (*Phasianus colchicus*) in full breeding dress. 1 May 2007

this applied science now that global warming is having an impact on climate change.

Fortunately for Kew, meticulous records of the first flowering times of notable plants have been kept since the early 1950s by the Kew botanist Nigel Hepper. Since 2000 Kew has continued to monitor 100 plants; from these combined records we can see the average opening time of many of our well-known spring bulbs has advanced considerably. Most dramatically, the flowering time of wild daffodils (*Narcissus pseudonarcissus*) has leapt forward from early March in the 1950s to late January in the 2000s.

For the last decade, the British public have been encouraged to keep their own records via the BBC SpringWatch Survey. These have been coordinated by the UK Phenology Network, which is run by the Woodland Trust and the Centre for Ecology and Hydrology.

With the onset of spring gradually creeping forward, birds are nesting earlier. Extensive studies in an Oxfordshire wood have found that the hatching times of both great tits (*Parus major*) and the winter moth (*Operophtera brumata*) caterpillars, on which they feed their brood, have gradually advanced and remained in synchrony. This is an encouraging trend but if the hatching time of other species of chicks becomes out of step with their insect food, the parent birds have to work harder to collect more, smaller caterpillars or else switch to an alternative food source.

This busy season for wildlife presents endless photo opportunities with attractive fresh green backdrops to spring scenes, individual portraits of male birds in their courtship finery or harmonious family groups.

far right

An adult Eurasian coot (*Fulica atra*) takes over nest duty after its mate leaves to forage. 10 April 2008

Beech leaves beginning to unfurl with reddish-brown bud scales still present. 6 May 2008

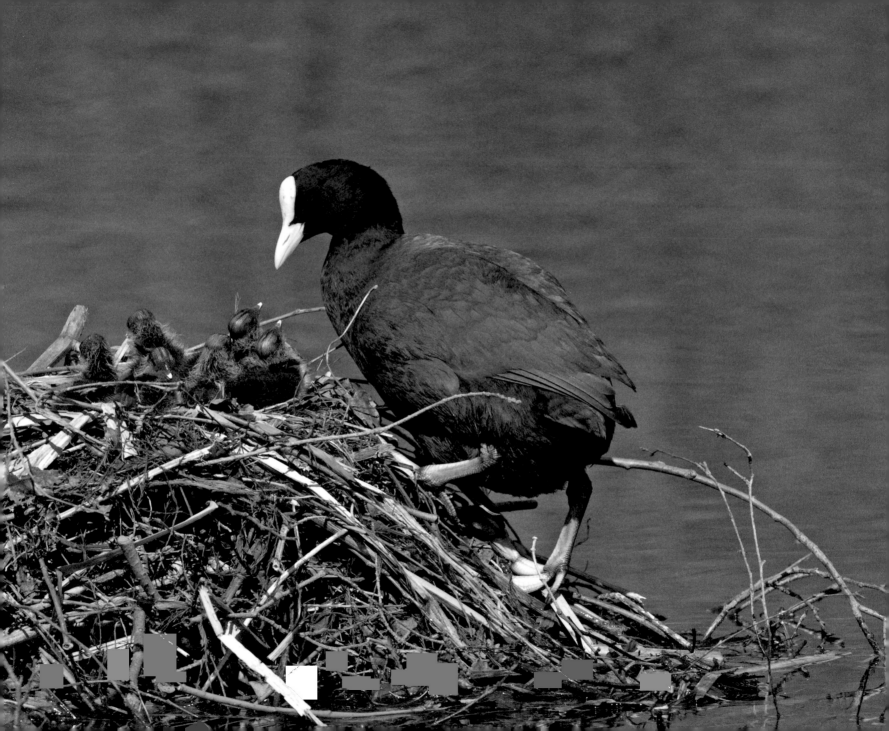

Harbingers of spring

As buds begin to break, pale yellow primrose flowers *(Primula vulgaris)*, one of the harbingers of spring, enliven patches of the woodland in the Conservation Area. The name for this plant - arguably the loveliest of our spring flowers - is derived from *prima rosa*, medieval Latin for the 'first rose' of the year. Long ago, primroses were closely associated with cows and here a local tradition provides us with another example of how spring has advanced: on the eve of May Day, primroses were rubbed on the cows' udders to ensure they produced plenty of milk for butter.

Primroses are dimorphic, which means that they normally occur in two distinct forms, distinguished by taking a close look into the heart of the flowers. The five primrose petals are fused at the base to form a long tube. Pin flowers have a pale green stigma in the centre of the flower at the top of the tube and the stamens lower down; whilst in thrum flowers their positions are reversed with the yellow stamens visible above the stigma below. Cross-pollination occurs as an insect forages from one flower to another and transfers pollen from a pin to a thrum flower and vice versa. In some parts of Britain there is a third, rarer form of primrose which has the stigma and stamens on the same level. This homostyle form, although self fertile, is rare: its copious small seeds have a lower percentage germination rate than the large seeds produced by the thrum and pin primroses.

Appearing a little later than primroses, but overlapping with them, is the long stalked cowslip (*Primula veris*) bearing smaller, deeper yellow flowers. Also in the primrose family, the common name is derived from cowslop (cowpat), a consequence of this species' abundance in meadows grazed by cows; but the use of herbicides and ploughing of grasslands have resulted in their decline. Since then, planting in roadside verges and on roundabouts have made cowslips more visible to passing motorists. Cowslip flowers have long been gathered to produce a delicate country wine and the plant was popular in Elizabethan knot gardens.

Like beech, the newly open leaves of European hornbeam resemble miniature pleated skirts, here covered by a late snowfall. 6 April 2008

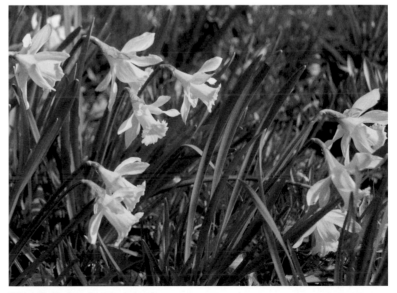

Wild daffodils dance in the wind in the Conservation Area. 21 March 2009

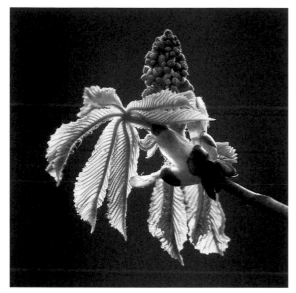

Backlit horse chestnut *(Aesculus hippocastanum)* bud with sticky scales, palmate leaf and emergent flower spike. 12 April 2008

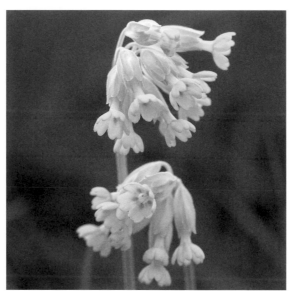

Cowslips with their small, dark yellow flowers are not nearly so plentiful in the Conservation Area as primroses. 26 April 2008

Pleated leaves begin to unfurl as a beech bud breaks in spring. 6 May 2008

A primrose bud peeks through snow beside its textured leaves. 6 April 2008

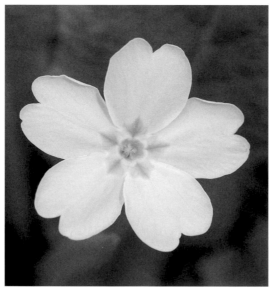

A thrum-eyed primrose bears yellow stamens above the lower stigma. 20 April 2008

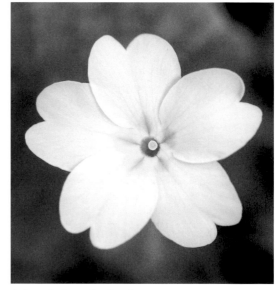

A pin-eyed primrose has the stigma uppermost. 20 April 2008

Nest building

PHOTO TIP

It is easy to photograph birds at work collecting nest materials: they spend more time on this task than they do collecting food to feed their young.

top

A magpie in a London plane tree (*Platanus* x *hispanica*) carries a twig to add to a large dome-shaped nest. 10 April 2008

bottom

Moorhens chose to nest in a skiff amongst a Chihuly glass installation in 2005 – the colours coordinating with the moorhen's red and yellow bill! 10 June 2005

Before nest building begins, territories have to be established and the noisy territorial battles on water involving coots and moorhens (*Gallinula chloropus*) are the most obvious. There is typically much wing flapping and birds may rise up out of the water to interlock their feet. With particularly vicious fights, birds can get injured.

When it comes to nest building, coots prefer a site completely surrounded by water, which deters terrestrial predators – such as foxes (*Vulpes vulpes*) – from gaining access. Coots, like moorhens, use their bills to ferry reeds, twigs or leaves to their partner constructing the nest. Fallen branches or a dead reed mat make a good base onto which vegetation is piled until the nest is 8–28 centimetres (3–11 inches) above the water level. Should the water rise, the nest is simply built up higher. Moorhens, on the other hand, usually select a site amongst vegetation beside a pond or lake. A highly original – and colourful – site selected by a pair of moorhens at Kew in 2005, was amongst a Chihuly glass installation on a Thames skiff.

Mute swans (*Cygnus olor*) are monogamous birds that mate for life and reuse the same nest year after year, making any necessary repairs each season. The nest is a large mound constructed at the edge of a wide expanse of water; one pair selected beside the Palm House Pond in 2008. Swans, as well as geese, also favour using the islands on the Lake as nest sites, some even recycling them! Shortly after a Canada goose (*Branta canadensis*) nest at the base of a swamp cypress tree (*Taxodium distichum*) was vacated in 2008, a pair of bar-headed geese (*Anser indicus*) moved in!

Terrestrial birds are equally busy gathering nesting material in early spring. They can be seen tugging at grasses and foraging in leaf litter before they fly across the Gardens carrying twigs, leaves, grasses or feathers in their bills. Magpies (*Pica pica*) build their conspicuous nests from twigs and wire in tall trees. Easily visible after leaf fall, each nest has two sections; a typical cup shape with a domed roof of prickly branches. Magpies love to adorn their nest with any shiny objects, from jewellery to silver foil.

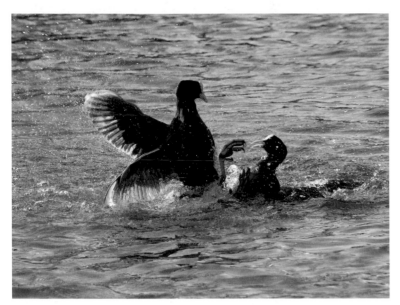

Coots fight on the Lake, spreading their wings backwards in the water so they can attack their opponent with their claw-bearing lobed feet. 26 December 2008

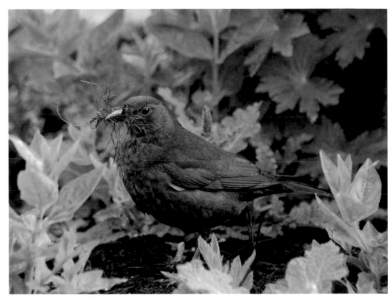

A hen blackbird *(Turdus merula)*, collects roots for building its cup-like nest made from twigs, stems and roots bound together with mud. 2 May 2008

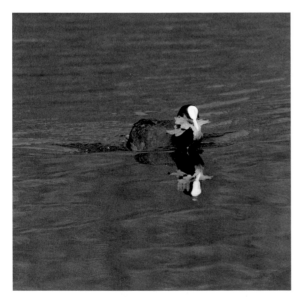

A Eurasian coot carries dry oak leaves to add to its nest. 10 April 2008

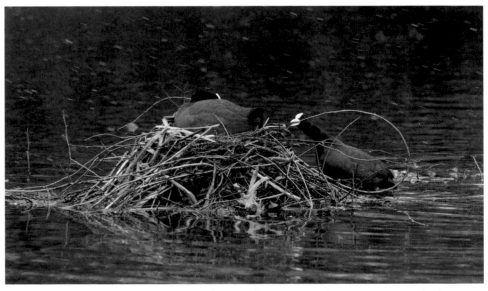

During a snow shower, a coot returns to its nest on the east end of the Lake with a long willow branch. 6 April 2008

13

Cones and catkins

PHOTO TIP

Catkins show up best if they can be isolated against a plain uncluttered backdrop, such as blue sky; but with Kew being on the direct flight path for Heathrow, watch out for vapour trails.

Long before primroses and bluebells carpet woodland floors, flowers begin to appear on trees. One of the earliest trees to flower is hazel *(Corylus avellana)*, which produces the catkins in the previous autumn before leaf fall. This means the yellow catkins are not dependent on buds breaking, they simply elongate; in a mild winter this can be as early as the beginning of January. When blown by the wind, microscopic pollen grains become airborne and get carried to the easily overlooked tiny upright red female flowers. After pollination, the female flowers develop to produce the hazel or cob nuts.

Goat or pussy willow *(Salix caprea)*, on the other hand, produces larger, sticky pollen grains that get transferred to a female catkin by bees and early spring butterflies which visit the flowers and carry pollen away on their bodies and legs.

European larch *(Larix decidua)* is the only native deciduous conifer in Britain. As the fresh green needles begin to appear the red larch 'roses' – the female flowers – sit upright on the branches ready to receive the wind-borne pollen from the rounded male flowers. After pollination, they develop into the first year green cones which mature to form the brown woody cones the following year.

In May, conspicuous catkins develop on common walnut trees as the attractive bronze foliage begins to appear on last year's shoots. The small female flowers with green flask-shaped ovaries and yellow styles emerge from the new shoots. Pendulous male catkins can also be seen on silver birch *(Betula pendula)*. If a hot snap follows after a prolonged cooler period, the catkins tend to release their pollen all at once instead of over a staggered period. In May 2006, residents in north-east Britain were mystified to find custard yellow dust coating everything – most noticeably on their cars – as well as forming a yellow film on ponds and puddles. This was due to the time of mass pollen release from Scandinavian birch trees coinciding with prevailing winds blowing to Britain from this part of Europe. Birch pollen is the main cause of pollen allergies in north European countries, whereas some people living in London have an allergy to London plane pollen.

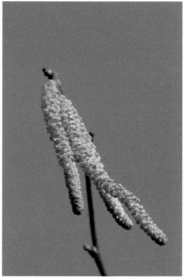

The male catkins of hazel, also known as lambs tails, disperse their pollen as they blow in the wind. 31 January 2009

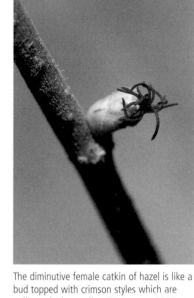

The diminutive female catkin of hazel is like a bud topped with crimson styles which are pollinated when pollen. 31 January 2009

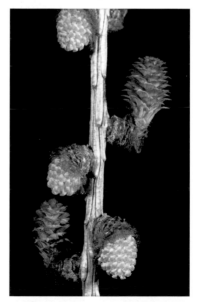

Male and female cones or catkins of European larch appear on the same branch. 30 March 2008

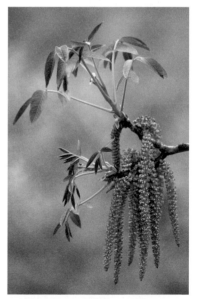

Walnut male catkins open at the same time as the new ephemeral bronze leaves. 7 May 2008

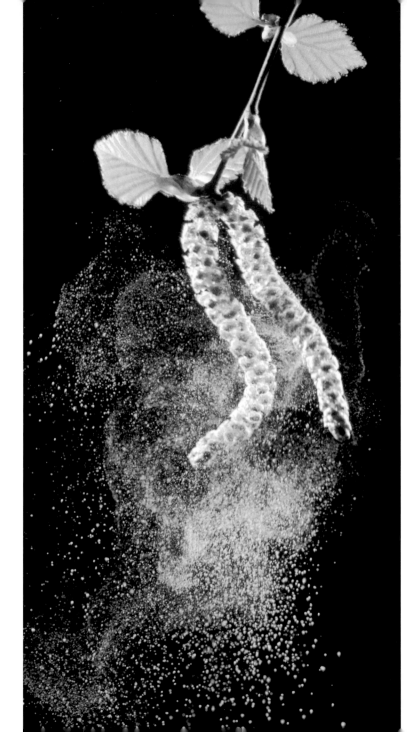

left

Pendulous silver birch catkins disperse a pollen cloud of microscopic pollen grains, some of which wafts onto the erect female catkins. 17 April 2008

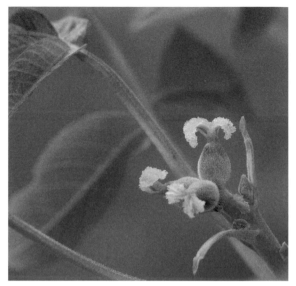

Female flowers of walnut are produced on the same tree as the male catkins. 10 May 2008

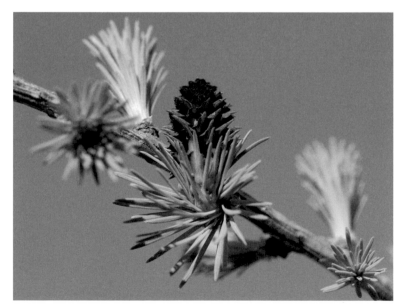

A larch rose, the female flower of European larch, opens just before the new green needles. 10 April 2008

15

Water babies

top

Mute swan cygnets wait patiently for food gathered by parent upending to reach green alga below the surface.
9 June 2008

bottom

A mute swan feeds young cygnets with green alga on the Lake.
9 June 2008

PHOTO TIP

Many adult water birds at Kew are habituated to people, but they are naturally protective of their young; better pictures will be gained by staying back and using the longest telephoto setting possible.

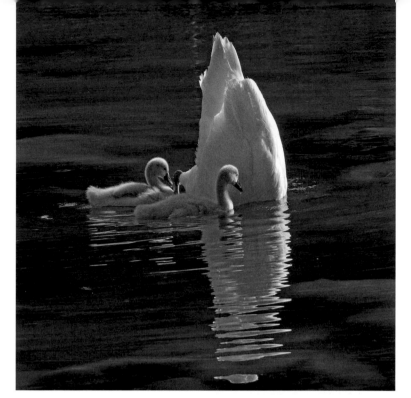

Young chicks and ducklings begin to hatch out in April, but May is the prime month for water babies. Then it is hard to keep pace with the new broods of baby coots and moorhens as well as ducklings and goslings that appear almost daily.

The Sir Joseph Banks Building Pond, the Palm House Pond and the Waterlily Pond all have chicks and ducklings, but mute swan cygnets will be seen only on the Lake and the Palm House Pond because adult swans need a good stretch of water for their long pattering take-off runs. The greatest variety of young water birds is to be found on or beside the Lake where the gently sloping shoreline provides easy access in and out of the water; while the islands provide suitable nest sites for swans and geese.

Initially moorhens and coots feed their chicks on the water, but as their offspring increase in size they will follow their parents onto land to graze. Young goslings spend most of the day out on land, grazing by plucking grass shoots with their broad bills, but they will also feed on water. The clutch size of mallards (*Anas platyrhynchos*) varies depending on the date of nest building and the available food, but averages around eight. Young ducklings have a job keeping up when their parents swim off at speed and frequently get separated; but their repeated squawking alerts a parent which swims back to round up the wayward chicks. Even so, baby waterfowl are attacked and eaten by herons (see page 80), carrion crows (*Corvus corone*) and foxes so that initial clutch sizes are reduced to a mere two or three offspring.

Mute swan cygnets feed on floating duckweed and green algal mats, as well as aquatic plants torn off by their parents. Like coot chicks, they hang around a foraging parent so they can be fed as soon as the swan surfaces. Adult swans gather aquatic plants either by stretching their long neck underwater or by upending with their tail uppermost to reach deeper plants. Grit is swallowed to help grind up plants in the gizzard. The brood of cygnets produced by the pair of swans on the Lake in 2008 gradually dwindled in size until eventually all were lost to predators, but in 2007 they successfully reared six young.

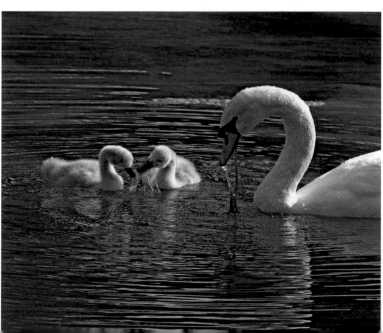

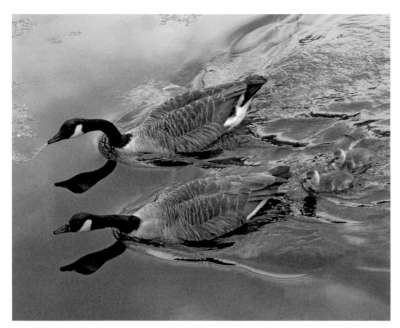

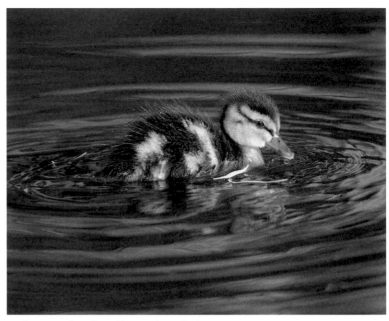

A Canada goose family swims amongst green alga towards the Sackler Crossing on the Lake. 21 June 2008

On the Sir Joseph Banks Building Pond a mallard duckling swims alone. 10 May 2008 or 8 May 2008

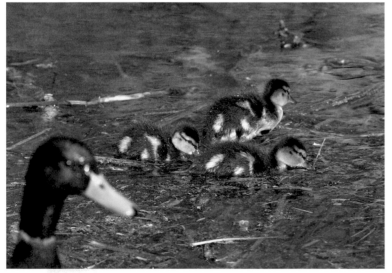

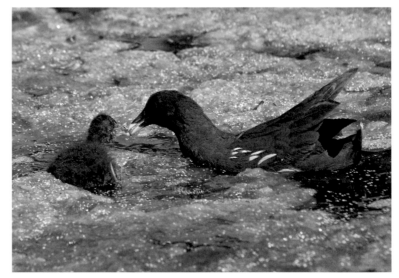

A mallard drake keeps an eye on his ducklings as they feed on the Lake. 12 April 2008

An adult moorhen feeds a chick amongst a raft of green alga on the Lake. 11 August 2008

Blooming trees

Horse chestnut flowers have a yellow centre at first and then turn red with age as the pollen is exhausted. 10 May 2008

The London plane is a vigorous hybrid between the oriental plane (*Platanus orientalis*) and the American plane (*P. occidentalis*). The constant renewal of the bark by sloughing has made it remarkably successful in withstanding London's previously highly polluted air, including the notorious smogs of the 1950s. The flowers, although not particularly showy, have a striking shape. As the leaves begin to unfurl, the yellow male and crimson female flowers appear on the same tree, clustered together in bobbles which descend as their stalks elongate. Wood pigeons (*Columba palumbus*) enjoy feasting on them before the flowers fully extend and wave around in the breeze.

The male flowers of common beech open very shortly after the leaves. Arranged in loose bobbles they are so plentiful they carpet the ground like confetti when they fall. The female flowers sit upright within a hairy cup.

Horse chestnut trees occur all over the Gardens, with several inside the wall on the south side of the Order Beds and many in the Conservation Area. It is impossible to miss the flower spikes standing up above the leaves all over the tree. From a distance they appear as large creamy chandeliers, yet a closer look reveals the centre of each flower changes colour with age. At first, they are yellow with the stamens projecting downwards, but change via salmon to red as they age and the stamens turn upwards. The flowers are pollinated by bees. The colour change signals to insects which flowers are newly opened and therefore worth investing time and energy visiting, since their pollen and nectar are still intact.

One of the latest trees to flower is the sweet or Spanish chestnut, thought to have been brought to Britain by the Romans. The male flowers are arranged on long catkins that resemble large hairy golden caterpillars and attract a host of insect pollinators; while the female flowers which arise at the base of some male catkins are small, green and spiky. Once pollinated they later develop into the spiky husked fruits. After the pollen has been shed the male flowering stems fall from the tree, apart from those that carry the female stems; these remain attached until the green spiny fruits ripen.

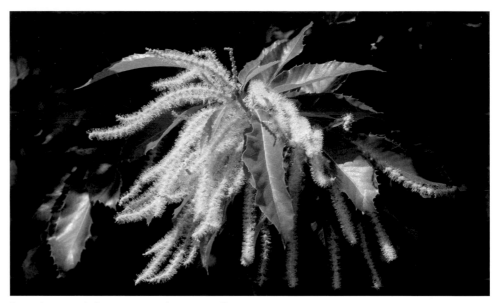

Sweet chestnut male flowers appear as long cream spikes and attract bees in midsummer. 27 June 2008

The female flowers of London plane appear as red bobbles when the leaves begin to unfurl. 22 April 2008

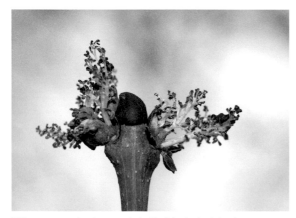

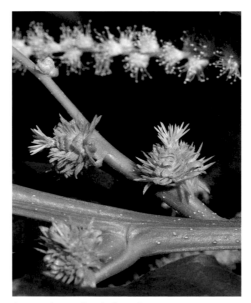

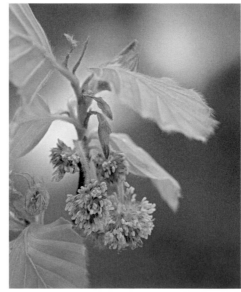

With snow carpeting the ground, the black buds of ash break to reveal tiny flowers before the leaves emerge. 6 April 2008

A sweet chestnut female flower has numerous stigmas. 30 June 2008

The male flowers of common beech are arranged in clusters on long stalks. 6 May 2008

Early birds

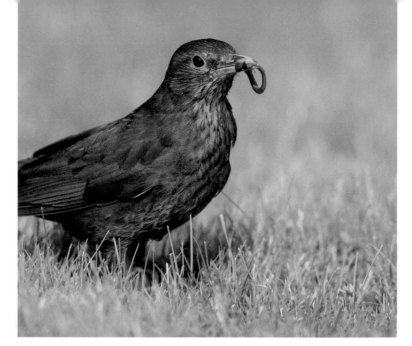

There's one less worm at Kew, as a hen blackbird pauses with its trophy. 15 June 2008

A fine early morning in spring is the best time for spotting a variety of birds feeding out in the open in parks and gardens. Grazers, such as moorhens and coots simply amble onto a lawn; geese and ducks may fly in.

Birds which forage on insects and worms have to work harder to find their food. Blackbirds and thrushes (*Turdus* spp.) will be seen making short forays (running or even hopping) across a lawn before stopping briefly to pluck a hapless worm or an insect. This pattern is repeated over and over again, with the birds not always being successful. Sometimes they may even be seen lowering their head and tilting it on one side for a few seconds to detect any movement of the prey.

Beaks are used to probe the ground. The jaw muscles of a starling (*Sturnus vulgaris*) work backwards; instead of using most of the power to clamp the bill shut, the muscles are also used to spring the bill open. The starling inserts the bill into turf where it is sprung open to expose hidden invertebrates. Starlings have the added advantage of being able to swivel their eyes forward to look along the length of their beak to the area being probed. Starlings have a varied diet, including food scraps, but they only feed insects, worms and snails – not junk food – to their young. These birds are especially fond of leatherjackets, the larvae of crane flies.

By June, family groups of magpies appear on lawns. Noisy youngsters, quite able to fly and feed themselves, still squawk to be fed. As well as invertebrates extracted from lawns, such as beetles, flies, caterpillars and leatherjackets, magpies also feed on birds' eggs, nestlings and even rodents. The name magpie is derived from a local name – Margaret's pie. When small garden chafers (*Phyllopertha horticola*) begin to emerge from lawns, birds may change their foraging tactics by leaping off the ground, deftly snapping up a beetle in mid-flight.

Many invertebrates shelter beneath leaf litter in shrubberies or beneath trees. Here, a blackbird will be heard rustling amongst leaves before it is seen deftly turning them over with its bill in search of insects and earthworms.

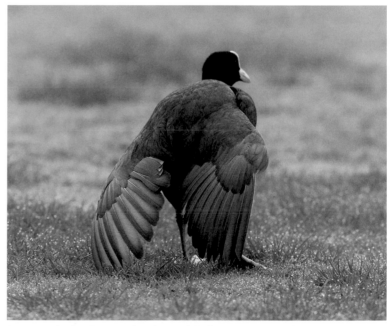

A coot stretches its wings on a dewy lawn early in the morning. 30 April 2008

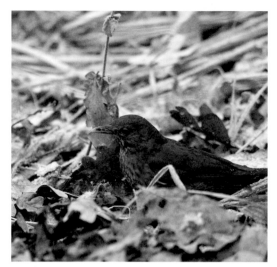

On a frosty morning a hen blackbird tosses an oak leaf to find insects hidden beneath. 7 January 2009

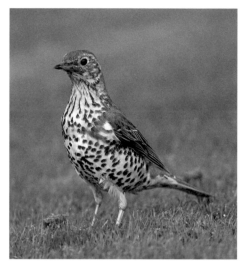

An alert song thrush (*Turdus philomelos*) lands on a lawn to feed at first light. 16 April 2009

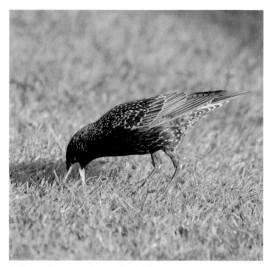

A starling has an early morning feed, showing its bill sprung open. 2 May 2008

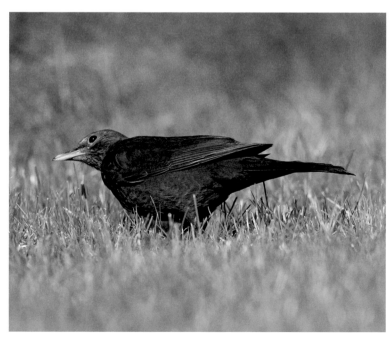

A hen blackbird tilts its head to listen for prey movements. 15 June 2008

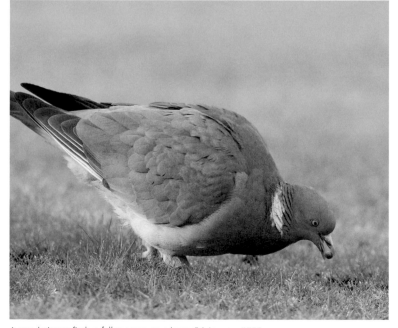

A wood pigeon finds a fallen acorn on a lawn. 24 January 2008

True blues

PHOTO TIP

Achieving the true blue colour of bluebells is much easier with digital cameras than with slide film, because the flowers reflect far-red and infra-red wavelengths which make them appear pinkish on some films. For the best blues, take freshly-opened flowers on a cloudy day or in a shady part of the woodland.

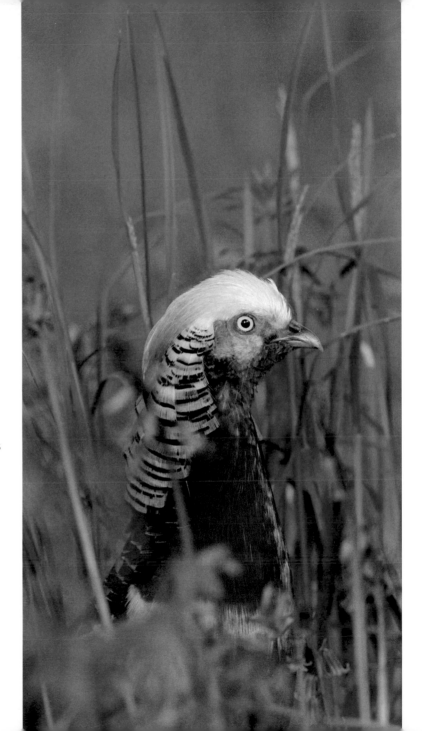

A gaudy male golden pheasant parades amongst the bluebells.
2 May 2008

One of the most glorious spring sights at Kew is the azure carpets of bluebells within the wooded Conservation Area. Tucked away in the eastern corner of the Gardens close to the Thames, the shortest route to the bluebells is via Lion Gate. The prime time used to coincide with the May Bank Holiday, but warmer springs have encouraged earlier flowering. Cooler, wet weather will prolong the time the flowers look their best. In 2008, heavy rain flattened the leaves but the sturdy flower stems remained upright.

Bluebells, also known as wild hyacinths, are a very special part of our British heritage; yet we tend to take them for granted. Only when we travel across the Channel do we appreciate that - with the exception of a few French woodlands - these bluebells are absent from mainland Europe. Over the centuries, British poets have written ecstatically about bluebells, notably Alfred, Lord Tennyson (1809–1892) who likened them to blue sky repeatedly in his poems. In 'Guinevere' we find '*...sheets of hyacinth / That seemed the heavens upbreaking through the earth.*' (Guinevere' ll. 387–88)

In some areas, patches of wild garlic flowers intermingle with the bluebells; while erupting through the blue carpets are the attractive, taller, lime-yellow, perfoliate alexanders, which has become a pest at Kew (see page 33 pic).

When strolling past the bluebells, the air will invariably be punctuated by the raucous calls of golden pheasants (*Chrysolophus pictus*), which originate from China and are part of the ornamental bird collection at Kew. If you are prepared to linger you may well see the bejewelled males sharing your path or strutting amongst the bluebells showing off their gaudy dress to a drab female.

But an invasive bluebell from Europe threatens this idyllic spring scene. The vigorous Spanish bluebell (*Hyacinthoides hispanica*) has been grown in British gardens since the seventeenth century and, together with the hybrid formed with our native species, is fast invading gardens and woodlands.

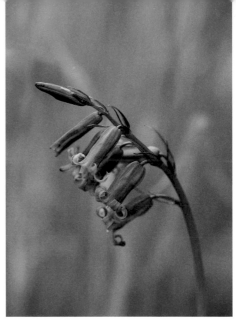

When the bluebells open, swards of breathtaking blue sheets transform the Conservation Area. 28 April 2008

Borne on a stem that bends near the top, the flowers of the native British bluebell have petals which curl back at their tips and cream stamens inside. 24 April 2008

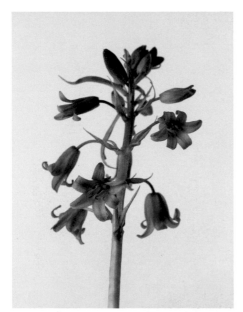

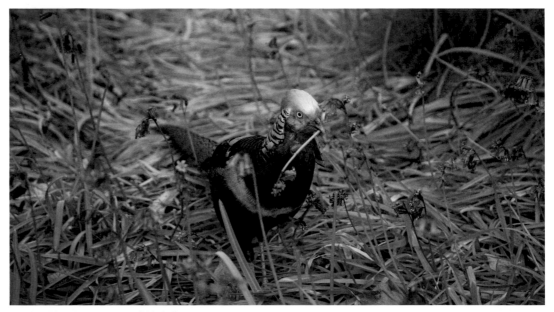

Both the Spanish bluebell and the hybrid formed with the native British bluebell have an upright stem and larger, paler, blue flowers with blue stamens. 5 May 2008

A male golden pheasant snaps off bluebell stalks to feed on them. 5 May 2008

Leftover lunches

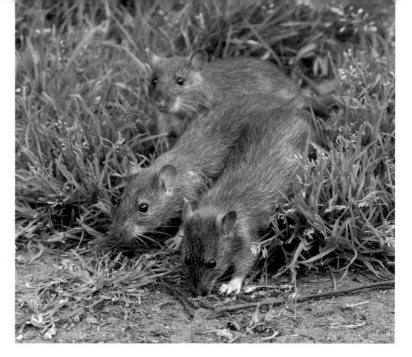

Three baby brown rats emerge nervously to forage on food spilt beneath bird feeders. 24 May 2008

Some animals are opportunist feeders that rapidly learn where to forage for free handouts. The bird feeders in the Conservation Area attract not only birds but also mammals. Grey squirrels (*Sciurus carolinensis*) are agile climbers aided by sharp claws that grip bark and a large tail which helps balance. They are renowned for their persistence and ingenuity to gain access to food; youngsters will even squeeze their way into squirrel-proof feeders!

Brown rats (*Rattus norvegicus*) at Kew also feed on bird food that falls out of feeders after a squirrel makes a hurried getaway. Even though rats are omnivorous they prefer protein-rich foods such as cereals. Typically nocturnal, rats have adapted to forage during the day, when the feeders are frequently stocked. Any sudden movement, such as people walking along the path, sends the rats rushing for cover inside a clump of nettles. But a short wait sitting on an adjacent seat will be rewarded by a cautious rodent re-emerging to feed. Throughout the day they can be seen making a speedy dash across from one side of the path to the other.

In the autumn of 2008, a young fox regularly visited the bird feeding area in broad daylight to forage on food split from the feeders. It approached along the path and squeezed under the rail fence to search beneath the feeders.

After visitors have left the Gardens and before the rubbish bins are emptied daily, squirrels and carrion crows move in to forage on leftovers. The outsized bill of carrion crows can amply handle half a burger and is also a vicious weapon for breaking open bird eggs or killing young ducklings and chicks. By perching on a high vantage point a crow gains a 360° view of the comings and goings of other birds. In this way it is able to pinpoint nests by watching birds carrying nesting materials, so that it can visit to steal the eggs later on. Birds which nest later, when trees have leafed out, are no safer because crows can spot them carrying food for their young chicks.

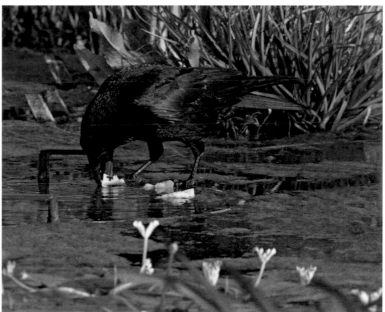

A carrion crow with the remains of a burger, snatched from a litter bin, dunks it in the Aquatic Garden at dusk. 6 May 2008

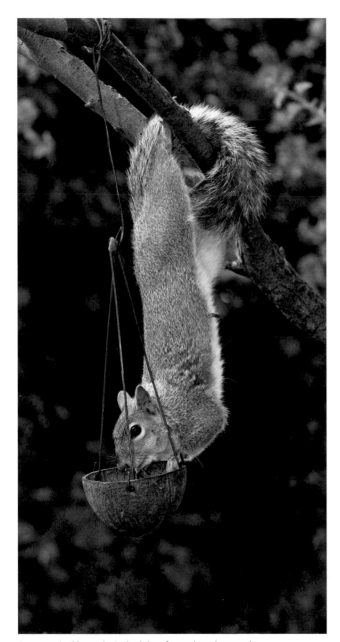

A grey squirrel hangs by its back legs from a branch to reach a bird feeder in the Conservation Area. 12 April 2008

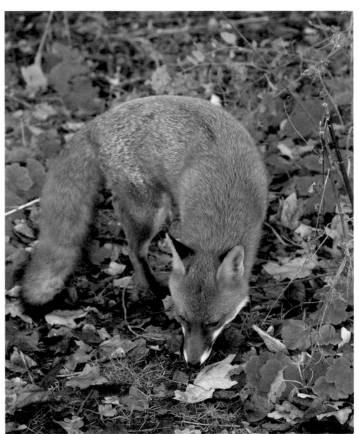

A young fox searches for food spilt by squirrels tipping the bird feeders.
25 November 2008

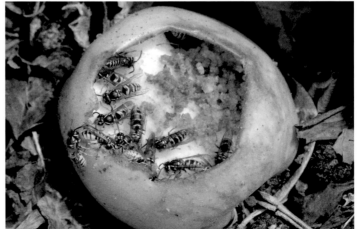

Wasps (*Vespula vulgaris*) feeding on a discarded partly-eaten apple.
15 August 2007

May time

PHOTO TIP

When taking a mass of white flowers – such as hawthorn – days with a light cloud cover are preferable to bright sunny ones, which produce harsh shadows.

Named after the Greek goddess Maia, the month of May is steeped in ancient customs. Traditionally, the first of May – known as May Day – marked the beginning of summer and in the past was celebrated as a major festival involving music and dancing around a maypole.

The hawthorn (*Crataegus monogyna*) is the only British tree to be named after the month in which it flowered; although nowadays, with flowers appearing as early as April in southern parts of Britain, May Tree is no longer such an appropriate name. On warm sunny days, the white flowers are abuzz with the comings and goings of insect traffic. In ancient times, the hawthorn was considered to be a sacred tree and a fertility symbol. Once it was thought unlucky to bring hawthorn flowers into the house; but now, hawthorn extracts are used medicinally to help control high blood pressure and cholesterol levels.

A famous hawthorn tree, known as the Glastonbury Thorn (*C. monogyna* 'Biflora'), first recorded early in the sixteenth century, flowered twice a year; in May on the old wood and around Christmas on the new wood. Considered to be 'miraculous', many cuttings were fortunately taken before this unique tree was cut down and burnt by Cromwell's soldiers.

The alternative name for the beetle known as a cockchafer (*Melolontha melolontha*) is maybug, seen on the wing throughout May. Attracted to lights, these brown beetles often crash against lighted windows. Male beetles can be distinguished by their feathery antennae, used to scent out a female. Maybugs were once very abundant but by the middle of the twentieth century their numbers plummeted, as a result of pollution. Therefore, the presence of maybugs indicates low pollution levels.

About a month after the female cockchafer lays her eggs, 10–20 centimetres below the surface, white grubs hatch out and feed on roots. They take three to four years to emerge as adults. Both the adults and larvae can do considerable damage to crops and forest plantations. In 1911, more than 20 million chafers were collected from just 18 square kilometres of forest.

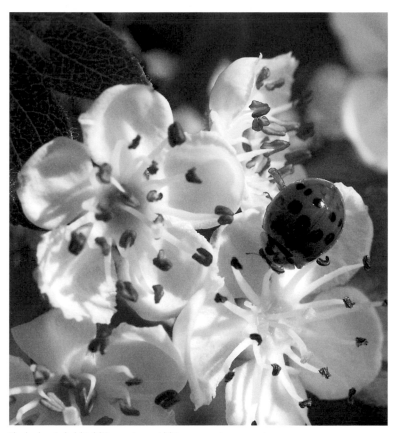

The harlequin ladybird (*Harmonia axyridis*) is one species amongst many beetles, flies and hoverflies that feed on hawthorn flowers. 14 May 2008

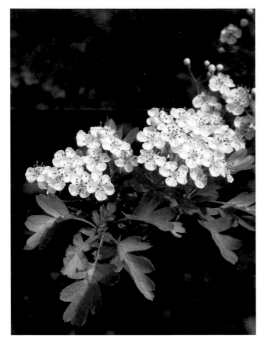

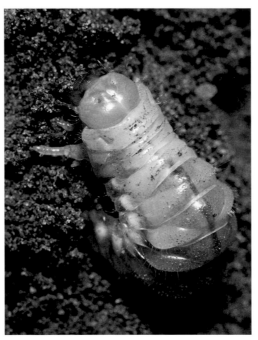

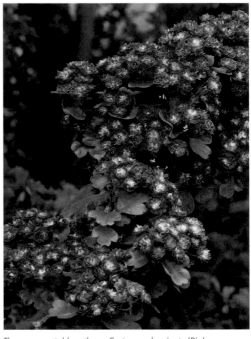

May or hawthorn flowers open with fresh pink stamens. 10 May 2008

The cockchafer larva lives in soil, where it feeds on roots. 10 November 2008

The ornamental hawthorn *Crataegus laevigata* 'Pink corkscrew' has contorted branches. 14 May 2008

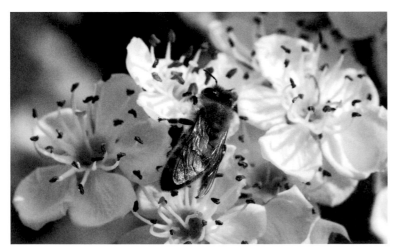

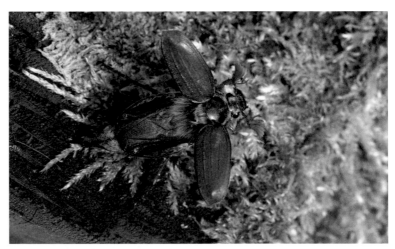

A honeybee (*Apis mellifera*) feeds on a hawthorn, *Crataegus meyeri*. 14 May 2008

A cockchafer, poised for take-off, shows the membranous wings beneath the hard brown wing cases. 10 May 2008

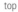

Raising a family

top

When the parents exchange nest duties the brood can be accurately counted - six fluffy chicks in this case. 10 April 2008

middle

The oldest coot chicks are the first to leave the nest so they get fed first when a parent returns. 12 April 2008

bottom

A pair of coots feed a young chick. The colourful red head and a curious fringe of orange feathers help the adults to spot the dark chicks in the water. 17 April 2008

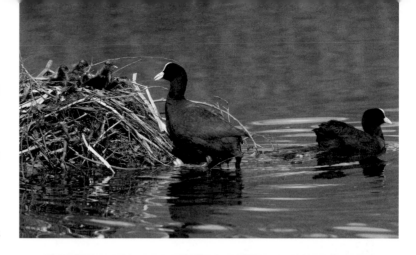

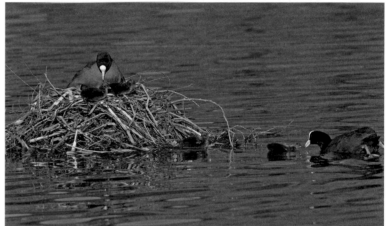

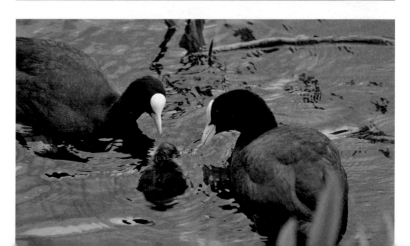

Coots are easily spotted at Kew, both on water - the Palm House Pond, the Lake, the Sir Joseph Banks Building Pond and the Waterlily Pond - or grazing on adjacent lawns. The Eurasian coot is the largest of all Britain's rails and has a black body, which can appear as a slatey-grey in some light, with a distinctive white bill and a white frontal plate above - hence the saying 'bald as a coot'. They begin nest building early in the year, fiercely defending their territory by running along the water surface towards any intruder, uttering a sharp metallic clinking sound.

In March, after a clutch of six to nine eggs is laid, both parents take turns to incubate for some three weeks. During this time more material is added to the nest, but by the time the chicks hatch out in early April the adults devote most of their time to collecting food for their young brood. For the first few days the chicks are fed on the nest; at first peeking out from beneath their parent's body. Within a few days, as soon as the most precocious chicks see a parent swimming towards the nest, they emerge and somersault down the nest so they can be fed first at the water's edge.

Shortly after this, the chicks leave the nest and stick close to their parents so they do not have to wait long to be fed. This also means that both parents can collect food and feed their brood. On a cold windy April morning, after an adult surfaced with a mass of green alga, it swam flat out towards the nest, followed by a line of straggling chicks. This was clearly a clever way to lure the chicks back to the warmth of the nest before embarking on another cold-water foray.

But inevitably some chicks stray too far from their parent's eye and get grabbed by a predator, with the result that at least half the brood is lost to herons or foxes. Sometimes, when food is short, the adults control the size of their brood by practising infanticide, by pecking at one of their chicks and refusing to feed it so that it starves to death.

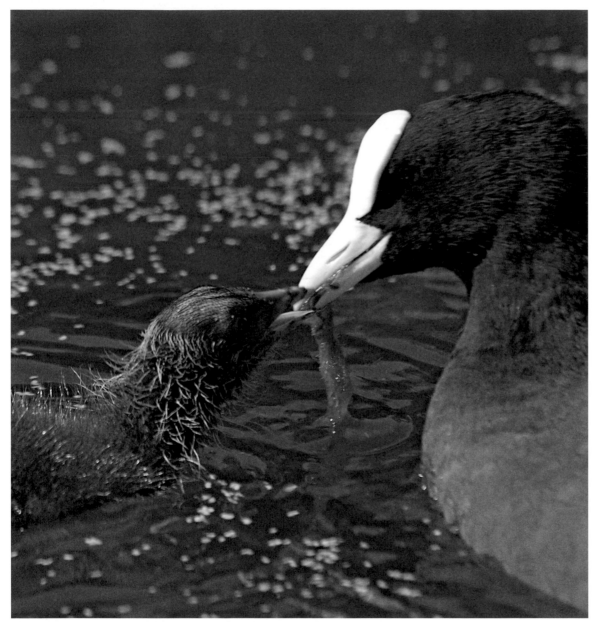

A coot chick feeds on green alga gathered from beneath the Lake by its parent. 17 April 2008

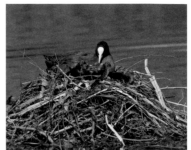

Six young coots on a nest peek out from beneath a parent. 10 April 2008

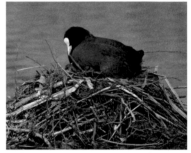

On water, coots eat aquatic plants, snails and insect larvae; but they also climb out onto land to forage on grass and will even eat earthworms. Here, as an adult attempts to swallow an earthworm, a young chick pecks at it. 10 April 2008

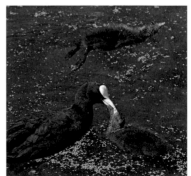

As a parent coot feeds green alga to a chick, another begs by stretching the neck forward and twisting the bill upwards. 17 April 2008

Noteworthy flowers

Some British wildflowers - such as buttercups (*Ranunculus acris*) - are notable because they form impressive floral carpets, which can be appreciated from a distance; others are more subtle and require a closer look at the individual flowers. Amongst the latter is the summer snowflake or Loddon lily (*Leucojum aestivum*), named from the Berkshire river where it grows. The pendulous white flowers tipped with green spots are common in the Thames Valley, where it thrives adjacent to rivers, on islands or within dense willow carr. At Kew it can be found beside the Lake and in the British plants section of the Rock Garden, near the waterfall. After bees have pollinated the flowers, the fruits develop flotation chambers. In times of flood, the fruits break off from the parent plant and are carried downstream, to become beached amongst tree roots and in thickets. There is some doubt as to whether this plant is a true native since it was not recorded in the wild until the eighteenth century.

Another plant in the Liliaceae family, also found in the Rock Garden, is the dainty snakeshead fritillary (*Fritillaria meleagris*). The flowers vary in colour from pink to white with a distinct chequered marking and grow naturally in wet meadows. Early in the day, when the sun is low in the sky, the flowers appear to glow like a lighted lampshade. One of the most famed fritillary sites is Christchurch Meadow at Magdalen College, Oxford; yet none of the many botanists who lived in the College mentioned it before 1785 when it was first recorded in the *Flora of Oxfordshire*. This casts doubt as to whether it is a true native; it is possible the fritillaries originated from plants cultivated in Tudor gardens.

Herb paris (*Paris quadrifolia*) is a rare plant with an inconspicuous flower, which is easily overlooked even when searching in ancient woodlands on calcareous soils, where it grows in the wild. It can be found at Kew in the British plants section of the Rock Garden. A single flower with eight erect stamens arises on a stalk above four leaves and after pollination a single black fruit forms, which is poisonous.

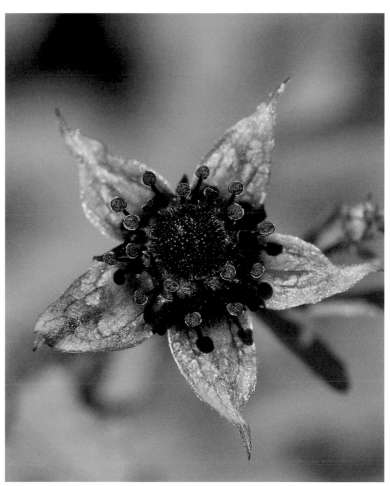

The star-shaped flowers of marsh cinquefoil (*Potentilla palustris*) can be seen beside water in the Rock Garden. 14 April 2009

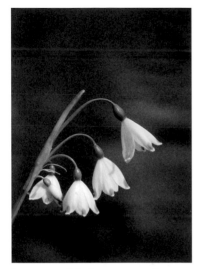

Summer snowflake flowers
beside the Lake. 17 April 2008

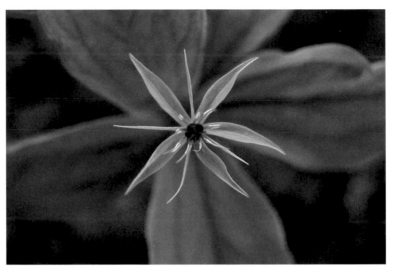

The understated green flower of herb
paris, in the Rock Garden. 6 May 2008

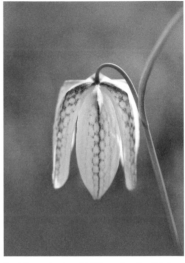

A white snakeshead fritillary showing faint
chequered pattern. 14 April 2009

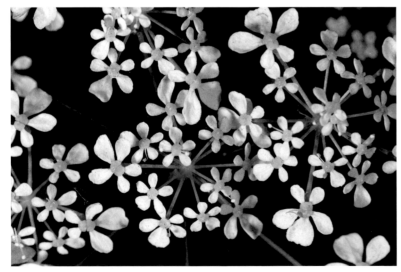

The white umbels of cow parsley flowers (*Anthriscus sylvestris*), which line many a hedgerow and
grow in the wild long grass areas at Kew, are exquisite when seen at close range. 12 May 2008

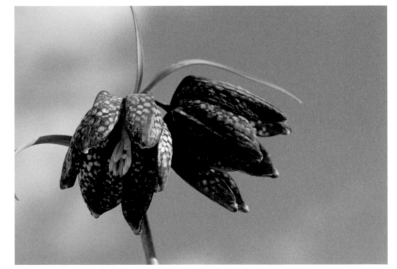

The pendulous flowers of snakeshead fritillary
with their chequered petals. 17 April 2008

Alien invaders

top

In south-eastern Britain, the rosemary beetle is becoming a pest of rosemary and lavender. 18 May 2008

bottom

Larva of the orange with black spots form of harlequin ladybird was found on Nootka lupin (*Lupinus nootkatensis*) in the Order Beds. 14 July 2007

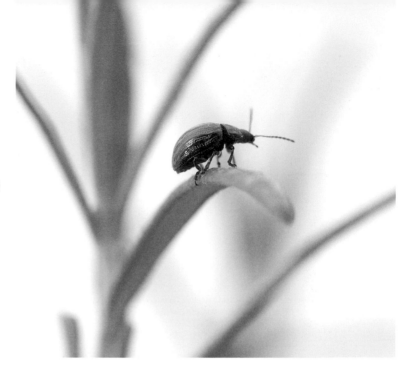

Deliberate and accidental introductions of alien plants and animals have been made into Britain over the centuries. Today, British gardens are a fascinating blend of plants that originate from around the world.

Perfoliate alexanders is an attractive 1.5 metre high biennial or short-lived perennial, with yellowish-green leaves similar in colour to some euphorbias. Deliberately introduced to Kew, this plant invaded the Conservation Area and became a weed that threatened the glorious bluebells. The colour combination of the azure blue and the yellow is stunning, but the taller perfoliate alexanders cast shade on the bluebells beneath. In an attempt to control the invasive plants, volunteers assist on a concentrated pulling after the bluebells have faded and before the alexanders have dispersed their seeds.

The harlequin ladybird is a large species, which first appeared in the UK in Essex, in 2004. Known also as the multi-coloured Asian ladybird and Halloween ladybird, it originates from Japan. It was introduced to Europe as a means of biological control for aphids and could have reached Britain on imported flowers and plants, or in cars returning to our shores. Since its arrival the harlequin has spread north and west within the UK, reaching Ireland and Scotland in 2007 and the Orkney Islands in 2008. This fast-growing ladybird feeds on aphids and so competes with our native species; in addition, the large and voracious larvae also prey upon our native seven-spot ladybird (*Coccinella septempunctata*) larvae. All stages of the harlequin ladybird show a red or orange and black warning colouration. The adults occur in several different colour forms and have been seen at Kew since 2005. During 2008 they were widespread in the Gardens.

The rosemary beetle (*Chrysolina americana*), which reached Britain from southern Europe, was first recorded in the Royal Horticultural Society's Garden at Wisley in 1994. During the last decade, scattered colonies have become established, particularly in the south-east. These attractive green metallic leaf beetles have become a pest of not only rosemary (*Rosmarinus officinalis*) but also lavender (*Lavendula* spp.). When the tips of these plants die back and go black these beetles are probably the culprits. They are easy to spot at night when their metallic wing cases shine in torchlight.

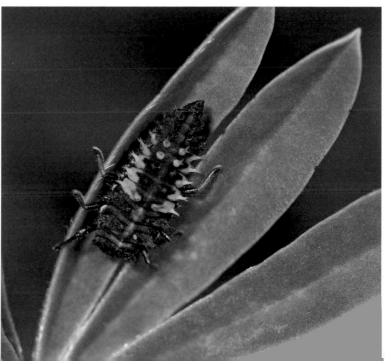

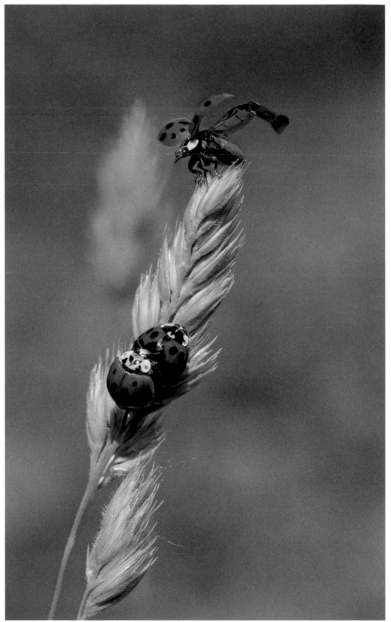

A single perfoliate alexanders stem rises above a bluebell carpet. 2 May 2008

A pair of harlequin ladybirds mate, while another prepares to take flight. 31 May 2008

Courtship rituals

PHOTO TIP

Avoid using flash when taking a peacock displaying; the full beauty of the iridescent fan feathers will be lost with unidirectional light.

Some male birds go to extreme lengths to court their mate, none more so than the stunning display by the peacock, which has favourite display sites. Blue or Indian peafowl (*Pavo cristatus*) frequent the area around the Waterlily Pond and the Japanese Gateway.

In spring, the raucous calls of the males make it easy to home in on them. At this time of year, the long train of some 200 iridescent tail feathers is at its prime, and most of these have distinctive eye spots at their tips. The peacock performs his courtship dance by raising the feather train, held upright by the grey tail coverts behind. He slowly and gracefully rotates on the spot so the feathers change colour as their angle to the light varies. When a peahen approaches the peacock he turns his back towards her, displaying the drab underside; but if she backs away he turns around to show off his finery, dropping the train over the female and quivering to rustle the feathers. If the peahen declines to mate the peacock repeats the display again and again.

Healthy peacocks display for a longer time and more frequently than less fit birds. The train feathers are shed and regrown each year and are collected for decorative uses. In Asia the feathers are used to make fans, earrings and even brooms.

The golden pheasant is one of many Chinese pheasants which can be seen in ornamental bird collections in the West. The best places to see the males (the females, like the peahens, are quite drab) at Kew are in the Conservation Area and the Rhododendron Dell. The male has a golden-yellow rump and crown, a gold and black-barred cape with a russet chest and a metallic green mantle. The cinnamon and black tail feathers are so long they make up two-thirds of the total body length. During courtship, one or more males may encircle a female, spreading out their gold and black cape on the side nearest to the prospective mate so it covers the side of their face, leaving just the eye exposed. If not ready to mate, a female will escape by flying up into a tree where a male may follow her.

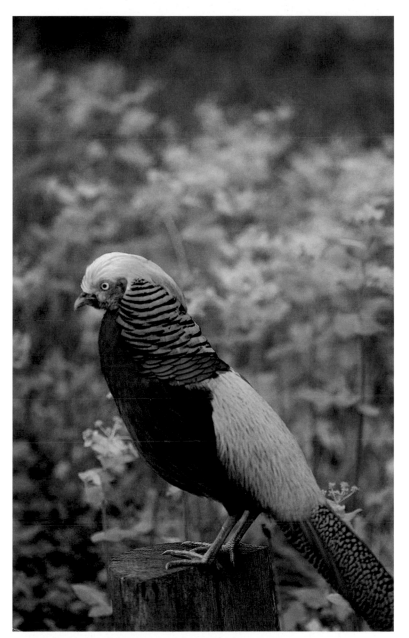

A male golden pheasant perches on a low fence in the Conservation Area with flowering bluebells and perfoliate alexanders in the background. 4 May 2008

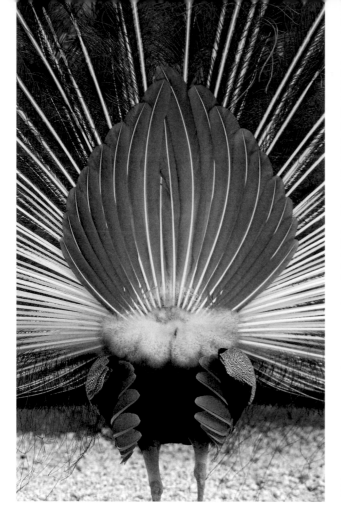

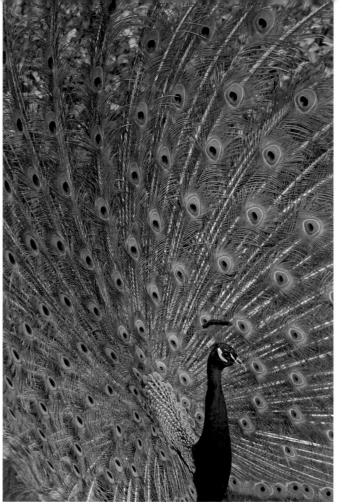

left

The rear view of a peacock reveals how the tail coverts support the erect fan display.
14 May 2008

right

A peacock displays his magnificent tail fan with an array of iridescent eye spots. 14 May 2008

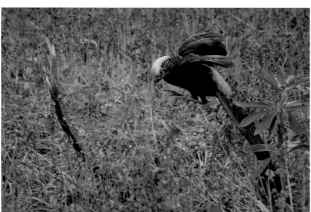

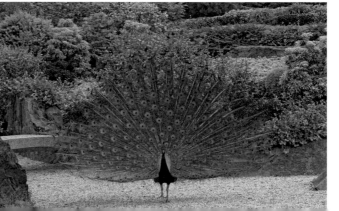

left

Male golden pheasants fight over female in bluebells. One bird leaps off the ground with his legs tucked up under the body.
5 May 2008

right

A peacock displays his complete tail fan near the Japanese Gateway, against a backdrop of flowering azaleas. 14 May 2008

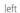

SUMMER

The transition as spring slides into summer is less marked than the interchange between other seasons. Waterfowl begin to raise a second brood and the longer daylight hours give birds in general more time to satisfy the voracious appetites of their broods, which are unable to feed themselves. Insects are by no means confined to summer, but this is the season when the majority of our attractive insects – butterflies, moths and dragonflies – are on the wing.

Butterflies enliven the Gardens as they visit wildflowers in the Conservation Area or annuals and perennials that have been planted elsewhere in the Gardens. Indeed, as many as 28 different species of butterflies have been recorded at Kew. For butterflies to flourish, they need plentiful nectar sources for the adults and suitable food plants for their caterpillars, as well as good weather.

With its persistent rain, the wet summer of 2007 prevented butterflies from being able to fly – either to feed on flowers or to find a potential mate. This meant that relatively few butterflies were on the wing in 2008 and, to make matters worse, this year had a very wet August with the result that butterflies were rarely seen. Optimum conditions for butterflies include a fairly dry summer with temperatures above 16°C. A prolonged period of very hot weather may affect the plants they feed on; so rain falling in brief periods is ideal for ensuring annuals and perennials do not wither and die prematurely.

The painted lady (*Cynthia cardui*) is a butterfly that migrates to Britain each year from Africa and Europe and then breeds here. Starting around the 2009 late May Bank Holiday, millions of painted lady butterflies began to invade Britain. The trigger for this mass migration – the largest for several decades – was heavy winter rain in the Atlas Mountains in North Africa, which produced a luxuriant growth of the caterpillars' food plants. These attractive butterflies with orange and black patterns plus white spots on the upper wings, remain in Britain until the autumn but, at present, are unable to survive during British winters.

Wildflowers such as these poppies, corn marigolds and corn cockle illustrate the floral diversity of the traditional wheat field before agricultural production became intensified. Taken at Kew in July

far left
Bumblebee with dark blue plum-hued pollen load forages on an Oriental poppy (*Papaver orientale*) flower.
24 June 2008

As our weather gets warmer, not only are flowering times gradually moving forward in the calendar (see page 8) but also alien insects are invading Britain from mainland Europe (see page 32). One insect originating from Europe, first reported in Southern England in 1940, is the bright red lily beetle (*Lilioceris lilii*) which can be seen on lilies in the Woodland Garden. The larvae are quite bizarre because they cover themselves with their own wet, black excreta. Both the larvae and the adults will eat the leaves, flowers and seed capsules of lilies and fritillaries.

Climate change is also affecting our native dragonflies. In 2008, the British Dragonfly Society launched a five-year survey because more than a third of our 39 native species are in decline. As the climate has become warmer some species are expanding their range northwards, but dragonflies in general need warm air in order to be able to fly and to feed. Dragonflies are highly beneficial in a garden as they prey on insect pests.

A delightful summer feature seen at Kew, in some years, has been the display of annual cornfield wildflowers along the Broad Walk and an area beyond the west end of the Lake. Some of the flowers, such as corn cockle *(Agrostemma githago)* are now rare in the wild; together with corn marigolds *(Chrysanthemum segetum)* and corn poppies (*Papaver rhoeas*) they enhance the wild populations of our native insects, which more readily home in on native plants than on many exotic cultivars.

Warm sunny days are ideal for checking out the different coloured pollen loads carried by honey and bumble (*Bombus*) bees. Not all pollen is yellow or orange; it may be white, pale green, purple or even black. A calm, warm evening is the perfect time to listen for the haunting stridulations made by grasshoppers and crickets in rough grassy areas.

far right

A multi-family group of Canada geese stride down Syon Vista. 8 June 2008

Lime hawk moth (*Mimas tiliae*) rests on ivy-covered bark. 10 June 2008

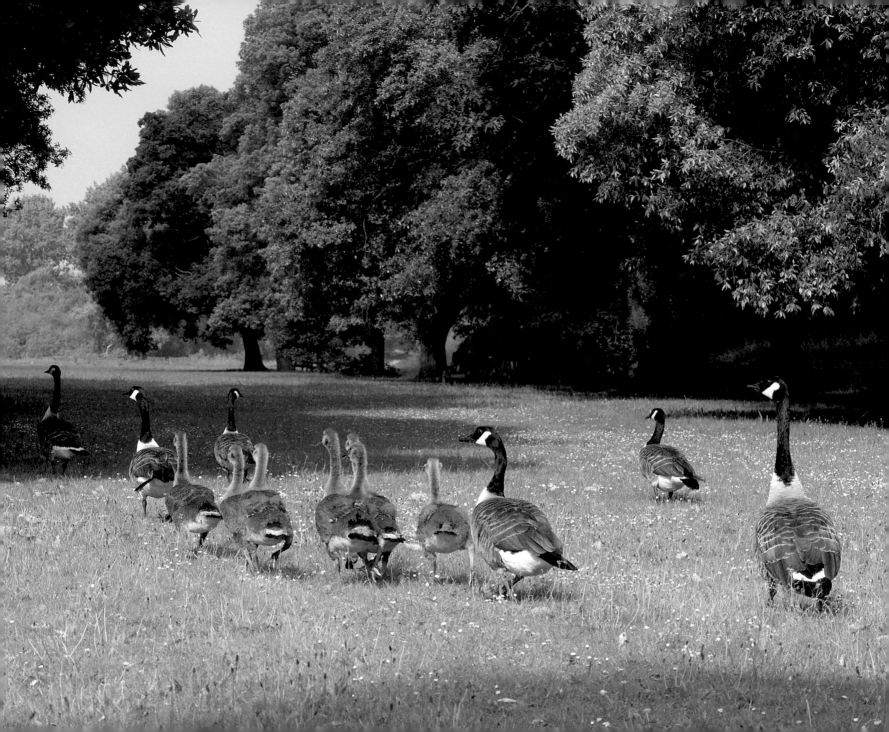

Defending territories

Be alert to alarm calls with
a camera at the ready to
record fleeting action.

After the time invested in nest building, egg laying and incubation, parent
waterfowl then have to try to ensure their offspring are kept safe from predators.
Any intruder that ventures too close to a coot's nest is swiftly seen off by a coot
running along the water surface creating an impressive line of splashes.

Moorhens also defend their territory from any intruders; young ducklings,
unknown moorhen chicks and even stray hedgehogs (*Erinaceus europaeus*) will be
seen off their territory with loud alarm calls. During the breeding season, moorhen
pairs can be heard screaming at any uninvited guests. Dedicated moorhen parents
are able to raise two or three broods every season, assisted by their older chicks
remaining in the vicinity. This helps with the workload for feeding and guarding
later broods and ensures the moorhen population is maintained.

Canada geese parents will vigorously defend their nest and offspring against
potential predators, including humans if they perceive them as a threat. Young
goslings can feed themselves but at first never stray far from their parents, who
keep a watchful eye on them. If other birds – or squirrels – venture too close, the
adults lower their necks adopting a threatening pose, and hiss. Even so,
youngsters still get attacked by carrion crows, foxes and herons, especially at
night which is full of dangers. Come dusk, the female signals to the newly-
hatched youngsters that she is ready to brood them, by ceasing to feed and either
sitting on the ground or stretching out her wings.

Large broods have to squeeze in tightly to gain the warmth and protection they
need in the early days, especially beneath the wings of smaller geese. Young
cygnets have the advantage of much more capacious swan wings for sheltering
beneath. When the goslings and ducklings get too big to be brooded they snuggle
up close to an adult at night.

Canada geese broods in the same vicinity may amalgamate. In 2008 three broods
from the Lake came together with six adults and, by then, a crèche of ten
goslings. This gregarious behaviour provides extra protection from predators with
more adults on the lookout.

A Canada goose leaps as a cob mute swan chases
it away from newly-hatched cygnets. 24 May 2008

Female mallard alarm reaction to four drakes chasing her and ducklings
on the Sir Joseph Banks Building Pond one evening. 8 May 2008

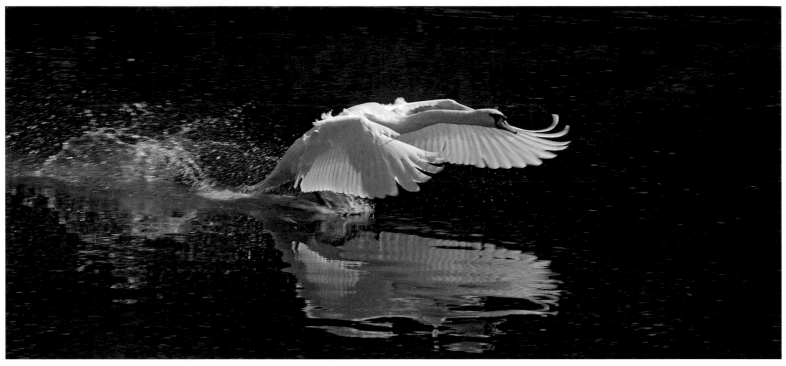

A mute swan charges down the Lake. 11 August 2008

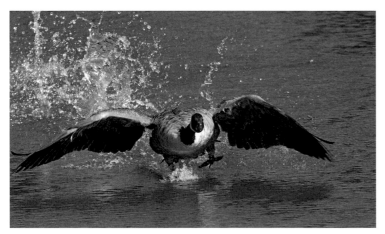

A Canada goose charges along the water towards
an intruder. 13 September 2008

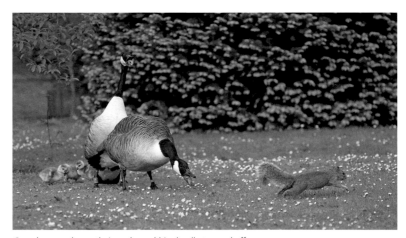

Canada geese lower their necks and hiss loudly to ward off a grey
squirrel venturing close to their newly hatched goslings. 2 May 2008

41

Shady characters

Ferns look their best early rather than later in the season when their fronds can become shrivelled from lack of water.

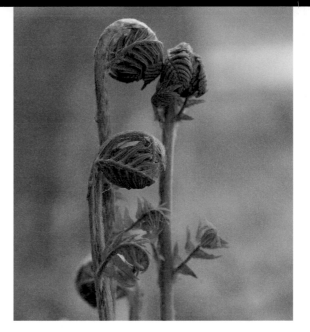

New coiled fronds or fiddleheads of the royal fern have a bronze tinge at first. 17 April 2008

By no means all plants flourish out in the open exposed to the sun, and many plants without flowers – such as mosses, liverworts and some ferns – thrive in permanently shady areas or where the sun shines only briefly each day. Some ferns are able to live in more open places providing they are rooted in moist ground.

At the west end of the Lake there is a patch of bare ground where the liverwort (*Marchantia polymorpha*) grows quite extensively. It is recognised by the creeping thallus on which small green cups appear containing tiny platelets or gemmae, produced asexually and dispersed by splashing raindrops. By June, erect diminutive stalked parasols appear; some have a flattened disc top (male heads) while others (female heads) are star-shaped. Liverworts also thrive on rocks within the humid cavern behind a waterfall in the Rock Garden and on rocks which are sprayed repeatedly in the Wet Tropics section of the Princess of Wales Conservatory.

The royal fern (*Osmunda regalis*) is, in various stages of growth, one of our most attractive native ferns. In spring, new buff-coloured stems with coiled tips, known as fiddleheads, appear from the hairy rhizome. These develop into large, spreading, fresh green fronds. In the centre of the clump erect, brown, fertile fronds appear covered with ginger sporangia that contain spores. In the wild, the royal fern favours growing in fens, bogs, wet heaths or damp woods. It also graces many a garden pond or lakeside. At Kew it is planted near the waterfall in the British plants section of the Rock Garden and on the south side of the Lake.

Often found amongst shady rocks or walls – especially calcareous ones – hart's tongue fern (*Asplenium scolopendrium*) can also be seen out in the open. The distinctive strap-like fronds with a heart-shaped base are thicker than many ferns and able to survive in full sun, such as on the wall of the Palm House Pond. The arrangement of the spore cases on the back of the older fronds resembles centipede legs, hence the specific name *scolopendrium* which is Latin for centipede. Occasionally hart's tongue plants may appear with lobed fronds or forked tips. These were much prized by Victorian gardeners when fern collections were in vogue.

Royal fern fertile tip surrounded by sterile green fronds. 15 June 2008

Gemmae cups on the liverwort
Marchantia thallus. 5 June 2008

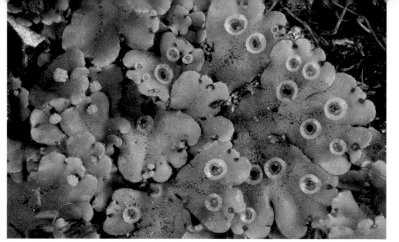

Tiny erect star-shaped parasols are the female
heads on the liverwort *Marchantia*. 5 June 2008

Harts tongue ferns have colonised a waterfall in the Rock Garden
and liverworts cover rocks in cavern behind. 31 January 2009

On the underside of the hart's tongue fern frond
are distinctive long straight sori. 24 January 2009

Parental care

Early in the day is a good time to see youngsters feeding with their parents on land or on water; after feeding all the family will spend time preening.

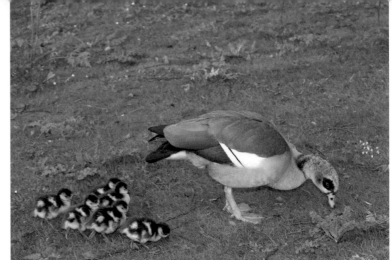

top
Newly-hatched Egyptian goose goslings stick close to a parent as they graze on grass beside the Lake. 6 May 2008

bottom
Three mute swan cygnets preen beside their parent on grass beside the Lake after an early morning feed on the water.
5 June 2008

All parents with young foraging offspring have to keep a beady eye or ear open for potential predators. They cannot allow their charges to swim too far from them by day, for sharp-eyed herons will soon swoop down and grasp one with their powerful bills. I have seen a heron take a young coot and another take a large duckling (see page 81). Alarm calls by coots will alert other birds to take defensive action such as scurrying down to the water away from a terrestrial predator.

At first, most waterfowl babies are unable to control their body temperature so their parents need to brood them. Usually it is only the female duck which broods, but in geese and swan families both parents cover the offspring with their body or wings, keeping them warm during heavy rain or at night, and protecting them from predators. Compared to ducks, swans and larger geese have much more room beneath their wings. For the first few days of their life, swans carry their fluffy cygnets with them when they take to water, when one or two can be seen peeking out beneath the wings.

An Egyptian goose (*Alopochen aegyptiacus*) family nested in a tree adjacent to the Xstrata Treetop Walkway and when the chicks hatched they plopped down to the ground. After grazing on lawns by day, the small goslings are brooded during the night. Even when quite small, six or eight youngsters have a tight squeeze to make it beneath the safety of either parent. Within a few days some will be lost to predators and one dedicated Egyptian goose lost a foot defending her brood, presumably from a fox.

As the Canada geese goslings grow, two or more families may combine to form a large group. Certainly they make a bold statement when they parade across a lawn and together they make effective peripatetic lawnmowers. Parent geese defend their offspring very forcibly by approaching any animal or human that invades their territory with a lowered neck and loud hisses. Swans tend to charge towards an intruder and flap their large powerful wings.

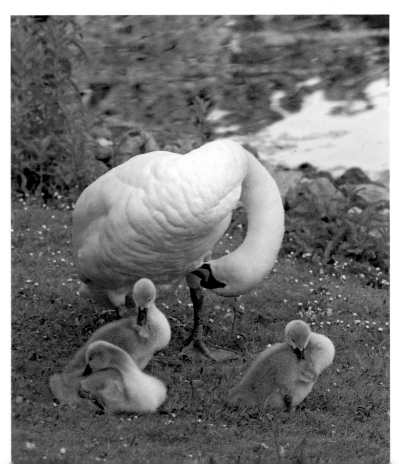

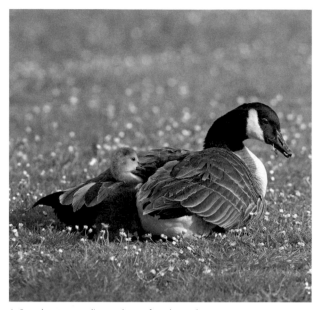

A Canada goose gosling peeks out from beneath parent's wing at dawn. 21 May 2008

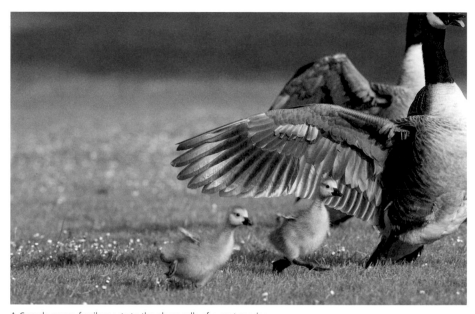

A Canada goose family reacts to the alarm calls of a coot sensing danger, by fleeing from land towards water. 21 May 2008

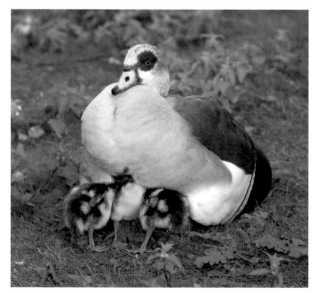

Six young Egyptian goose goslings huddle together beneath a parent for the night. 6 May 2008

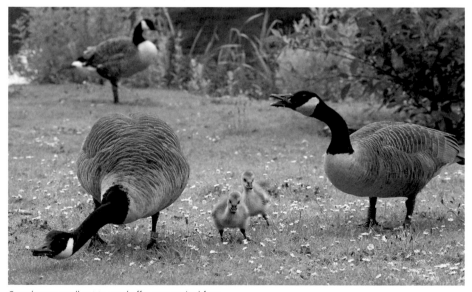

Canada geese call out to ward off a grey squirrel from approaching too close to newly hatched goslings. 21 June 2008

Foxes and foxgloves

If a fox is not in a hurry, it will stop and turn around; this is the time to start taking pictures before gradually moving in closer.

Foxgloves (*Digitalis* sp.) are the quintessential woodland flower, enlivening many a glade in the Conservation Area. The origin of the flower's name is from the Old English name *foxes glofa* and is based on an ancient myth that foxes wore these bell-shaped flowers on their paws to muffle their steps while raiding hen houses. These flowers are also associated with fairies, hence the names fairy bell, fairy thimbles and fairies' petticoats. As perennial plants, a leafy rosette forms in the first year and the striking flower spike up to 1.8 metres (6 feet) high with a mass of pink tubular flowers the following one. The whole plant is poisonous, yet the drug *digitalin*, obtained from the dried leaves, is still used to treat some heart conditions.

Foxes also live in woodlands. Although they are mainly active from dusk to dawn, on short winter days they may appear at any time of day. Early in the morning a fox, with its distinctive pointed muzzle and long tail or brush, may be seen as it trots along familiar routes returning to its den or earth, under a large tree root or in an old badger sett. Three to six cubs are born in March or April and on warm, sunny days the cubs can be seen sunning themselves and playing in secluded areas.

Adult foxes are skilled hunters, which have to hunt more actively when they have young cubs to feed. They catch live rodents, frogs, ground-nesting birds plus their chicks and will also feed on earthworms, autumn fruits (especially blackberries) and, if food is sparse, on beetles. When no live food is available, foxes scavenge on any carrion they come across. On the other hand, when there is superabundance of food, foxes will cache it.

Foxes' eyes have vertical slit pupils enabling them to hunt in variable light. The retina has many rod cells which function better in low light conditions than our own eyes and can detect movement. When hunting by day they rely on vision; whereas as the light fades their sense of hearing enables them to detect leaves rustled by prey.

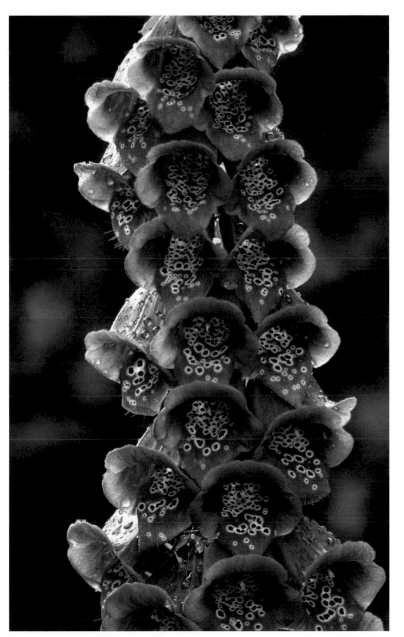

In midsummer, stately pink foxglove spikes enliven the woodland in the Conservation Area. 8 June 2008

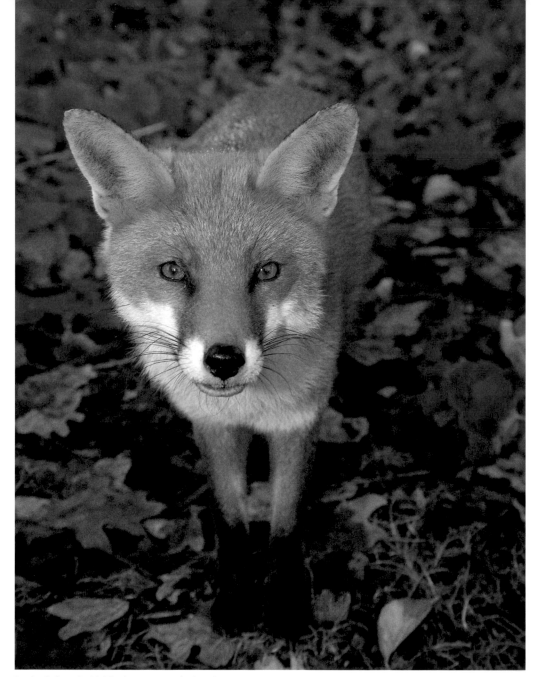

Food spilt from the bird feeders attracts a fox into the woodland within the Conservation Area. 25 November 2008

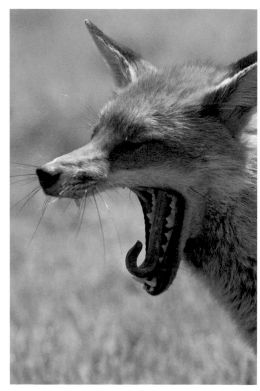

As a red fox yawns, the long tongue and pointed canine teeth are visible, together with the whiskers or vibrissae on the muzzle. 22 November 2008

Fox footprints show up well on a path after a light dusting of snow. 5 January 2009

Living on the edge

The male phase of flowering rush flower. 13 July 2008

The female phase of flowering rush flower. 30 August 2008

Many striking perennial plants that grow alongside water flower in summer and a good selection can be seen in the Aquatic Garden. An exception is marsh marigold or kingcup (*Caltha palustris*) which produces flowers as early as April or even late March. The shining yellow flowers arise from heart shaped leaves. Flourishing all over Britain and elsewhere in northern latitudes, the petals were once used for producing a yellow dye to colour paper.

A widespread marginal aquatic plant is the yellow flag iris (*Iris pseudacorus*), with spear-like leaves and showy flowers that open one at a time, two or three to each stem. The rhizomes of this plant, which can be seen before the leaves sprout in spring, produce a black dye and black ink. Colourful local names for the yellow flag iris include butter and eggs, ducks-bill and queen-of-the-marshes. Branched bur-reed (*Sparganium erectum*) leaves are triangular in cross section and the branching flower spikes carry male flowers at the top with spherical bur-like female flowers below. The flowers are wind pollinated and produce seeds that float on water for many months.

One of the stateliest of all our marginal plants, the flowering rush (*Butomus umbellatus*) is confined to southern Britain. It reaches over a metre in height and carries an umbel of 20–30 rose-pink flowers. Each flower has three distinct phases. On the first day the flower opens, the male stamens bear fresh pollen. The following day is a neuter phase when there is no visible pollen and the stigma surfaces are not yet exposed. By the third day the female phase develops with exposed and receptive stigmas.

Beside the Lake in mid-July, striking spikes of purple loosestrife (*Lythrum salicaria*) appear with reddish stems that are square in cross section. Charles Darwin discovered that this plant produces three different flower types, and so it is known as a trimorphic flower (see the dimorphic primrose on page 11). Flowers with long style flowers have short and mid length stamens, mid length styles have long and short stamens, while short styles have mid length and long stamens. All the flowers on a single plant are identical and can be pollinated only when pollen is transferred from another plant by a foraging insect.

Flowering rush is cultivated as an ornamental aquatic plant and can be raised from seed. 8 June 2008

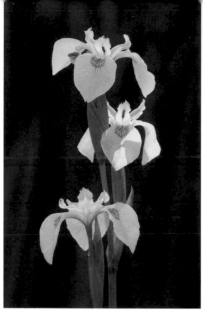

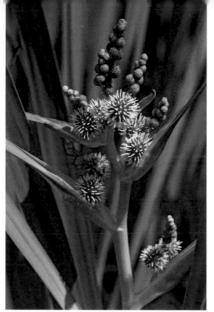

left

The multiple buds on each stem ensure the striking yellow flag iris flowers over several weeks beside the Sir Joseph Banks Building Pond, the Palm House Pond and the Lake. 21 May 2008

middle

When In flower, branched bur-reed carries male flowers above the larger female flowers. 8 June 2008

right

Stately flowering spikes of purple loosestrife have three types of flowers. 13 July 2008

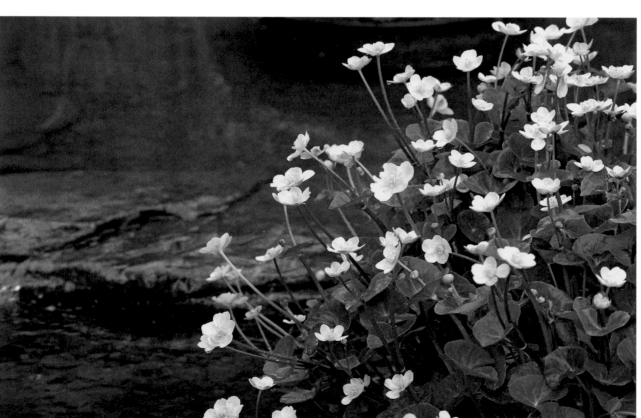

Marsh marigolds or kingcups grow beside streams, lakes and ponds and in wet meadows. 29 April 2008

Going fishing

Instead of rushing towards a heron, move forward slowly, stopping to see how it reacts. Take a picture each time you stop, then if it does fly away you will have some shots.

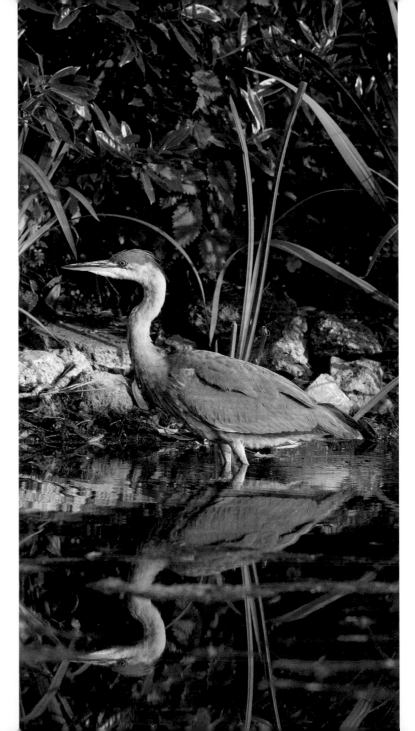

A grey heron is reflected as it wades into the Lake in the evening. 1 July 2008

Even when seen as a small silhouette in flight, a heron is unmistakable with its large wing span, long neck bent back towards the body into an S shape and long legs extended behind. Early or late in the day is the best time to see Britain's tallest bird, the grey heron (*Ardea cinerea*), beside the Lake or the Sir Joseph Banks Building Pond and even by the much smaller Waterlily Pond; although if they are hungry they will feed at any time of day. Herons constantly keep an eye on the whereabouts of young broods, flying from one side of the Lake to another to maintain a clear lookout.

At these times, solitary statuesque herons wait patiently for a fish to swim within reach of their yellow dagger-like bill. Just before striking, a heron stoops low, its long neck extended and a third eyelid – known as the nictating membrane – moves horizontally across the eye to protect it whilst underwater. Then it is all over in a flash. As head and neck plunge into the water, the wings are raised to balance the bird and prevent it falling forwards. If unsuccessful, a heron will repeat the process all over again, sometimes moving off to a new fishing location.

The prey – often impaled by the sharp bill – is taken to the water's edge. Here, the fish is turned around in the bill so it can be swallowed head first to prevent spiky fins from getting caught in the bird's throat. Fish form the main diet of herons but they also feed on frogs and small aquatic birds – especially young chicks if they stray from their parents. A photo sequence showing how a grey heron eventually drowned and swallowed a large duckling can be seen on pages 80–81. Mammals too, such as the odd water vole (*Arvicola terrestris*), can fall prey to herons, while grey squirrels are wary about moving down to drink when a heron is spotted on the bank.

Back in 1928, the grey heron here in Britain was chosen for the world's first national census of any bird. In severe winters, numbers of herons plummet when water freezes and they are unable to break through the ice to fish.

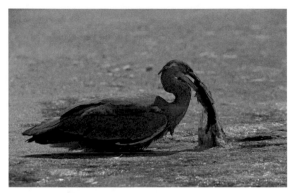

A grey heron wades out into deep water to catch a perch (*Perca fluviatilis*) with blanketweed at the edge of the Lake. 30 June 2008

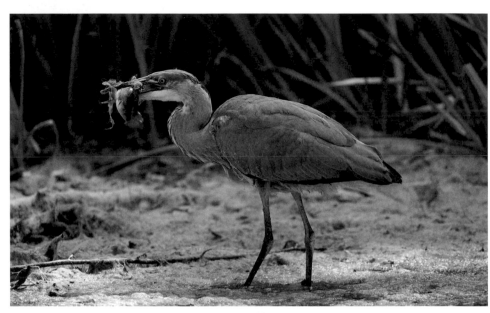

A grey heron takes a perch catch to the Lake edge, carpeted in blanketweed, to turn the fish around before swallowing it head first. 30 June 2008

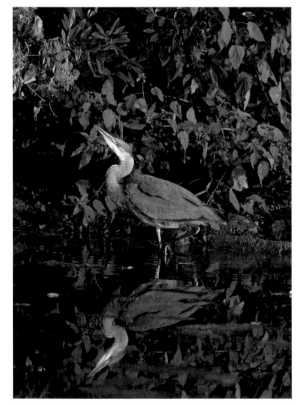

As a plane flies overhead, a grey heron looks skywards. 1 July 2008

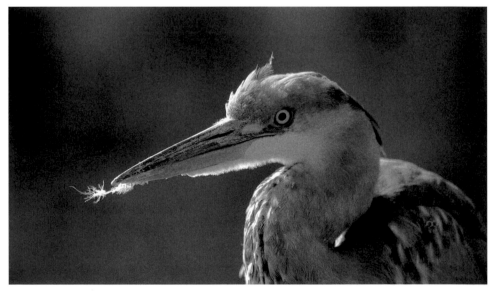

The heron's dagger-like bill is effective for stabbing fish, but cannot break through thick ice. Here it has been used to delicately preen the down feathers. 18 October 2008

51

A free lunch

Flash will be needed to light plant parasites growing in dark places such as woodlands.

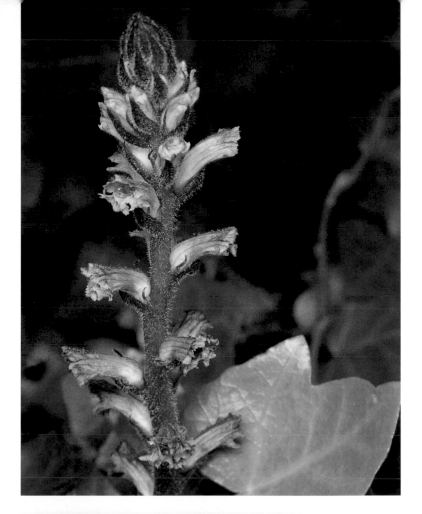

Ivy broomrape lacks any chlorophyll and is parasitic on ivy.
31 May 2008

Flowering plants that lack green chlorophyll cannot synthesise their own food from sunlight and sugars. Instead, each lives a parasitic existence tapping the food resources of their particular host plant.

Purple toothwort (*Lathraea clandestina*) is easily overlooked without knowing when and where to search. This perennial leafless parasite grows on the roots of willows, poplars and alders, producing two-lipped purple flowers just above the soil in April. Many flowers appear at Kew beneath a large black walnut (*Juglans nigra*) beside the path in the Woodland Garden. Large seeds are ejected by an explosive mechanism and are dispersed downstream where host trees grow beside water.

Broomrape flowers are easier to spot because they grow on stalks several centimetres high. When first seen, the brownish stems with cream or yellowish flowers appear more dead than alive but a close look reveals attractive distinctively patterned flowers. This group of parasitic plants is so named from one species which grows on broom and gorse. Ivy broomrape (*Orobanche hederae*) grows on ivy (*Hedera helix*) in several places at Kew: outside the School of Horticulture building and along the path running inside the wall beside Kew Road. Flowers of this broomrape can be found over a longer period than any other species.

Bunches of mistletoe (*Viscum album*) are traditionally sold all over Britain at Christmas. This plant lives as a semi-parasite on several deciduous trees, for most of the year hidden from view by tree foliage. But after leaf fall, spheres of green branching mistletoe stand out against the leafless apple or poplar trees on which they grow. Mistletoe has green leaves and stems, so it can produce some of its own food, extracting mainly water and minerals from its host. The white sticky fruits appear during the Winter Solstice – the beginning of a new year. They are an important winter food source for mistle thrushes (*Turdus viscivorus*) and other birds, which spread seeds via their droppings or by transferring the sticky coated seed to a branch as they wipe their bill clean. National Mistletoe Day, endorsed by Parliament in 2005, falls on the 1st December each year.

Detail of the cream flowers with purple veins produced by ivy broomrape.
8 June 2008

Purple toothwort grows on the roots of black walnut at Kew, flowering at the same time as wood anemones (*Anemone nemorosa*). 10 April 2008

Red stems of parasitic greater dodder (*Cuscuta europaea*) can be seen entwining stems of tall skullcap (*Scutellaria altissima*) in the Convolvulaceae bed within the Order Beds. 10 November 2008

Insignificant yellow mistletoe flowers develop into white sticky berries. The Druids decorated their homes with mistletoe to celebrate the onset of winter two centuries before the birth of Christ.

Life at the surface

PHOTO TIP

To get a close-up of duckweed in focus all over the frame, the back of the camera needs to be held parallel with the water surface.

The majority of plants associated with fresh water need an anchorage for their roots, whether beside a pond or stream or on the bottom. In more sheltered waters there are also a few plants that float freely on the surface, moved back and forth by wind, by waterfowl swimming through them or by surfacing fish.

Lesser duckweed (*Lemna minor*) lacks stems and leaves; in summer minute plantlets multiply rapidly by budding and can completely carpet a pond. Tiny flowers are produced only in sunny undisturbed places such as shallow ditches. This cuts out sunlight penetrating through the water and functions like a green screen placed between the sun and the water. Hidden below the surface are roots up to 30 times longer than the floating part, which makes it more of a worthwhile meal for ducks and swans.

Floating water plantain (*Luronium natans*), found in the Aquatic Garden, is a much more substantial plant with floating 2.5 centimetres (one inch) long oval leaves. After Britain's canal system was built, this water plantain spread eastwards from mid and north Wales – notably Snowdonia. However, dredging or channel straightening, as well as pollution, now threaten this species, which is being protected by British Waterways and several other partners.

The common pond skater or water strider (*Gerris lacustris*) is especially adapted to life on the surface. It literally walks on water, using its water-repellent cuticle and spread-out legs with microscopic hairs that trap tiny bubbles of air. On a sunny summer's day striders can be seen scurrying about as their long middle pair of legs row them across the water surface. They can also jump to escape from a predator. The dimples cast by their legs appear as round shadows on a shallow bottom of a duckweed-free expanse of water. Striders feed on dead or dying insects that fall into water, using sensitive hairs on their legs and body to home in on the vibrations and ripples created by the hapless prey. The strider's short front legs are adapted to catch and hold prey while their proboscis is used to pierce the prey and inject enzymes to break down the insides so the juices can be sucked out. Pond skaters hibernate during the winter and begin to appear in early spring.

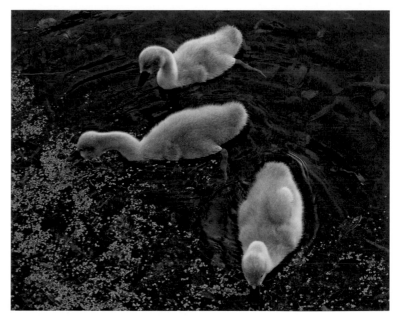

Three mute swan cygnets feeding on duckweed on the Lake at first light. 5 June 2008

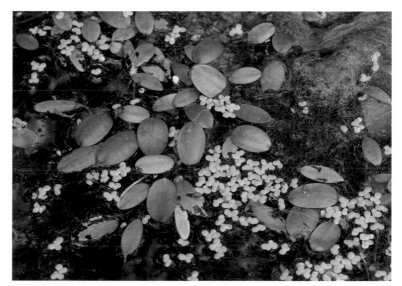

Floating water plantain carpets the surface, along with lesser duckweed. 24 May 2008

Lesser duckweed floats on water surface
in the Aquatic Garden. 15 June 2008

Shadows of dimples cast by pond skater feet resting on
shallow water in the Rock Garden. 4 September 2007

bottom

A pond skater walks on
water using surface tension;
note the dimpled meniscus.
23 August 2005

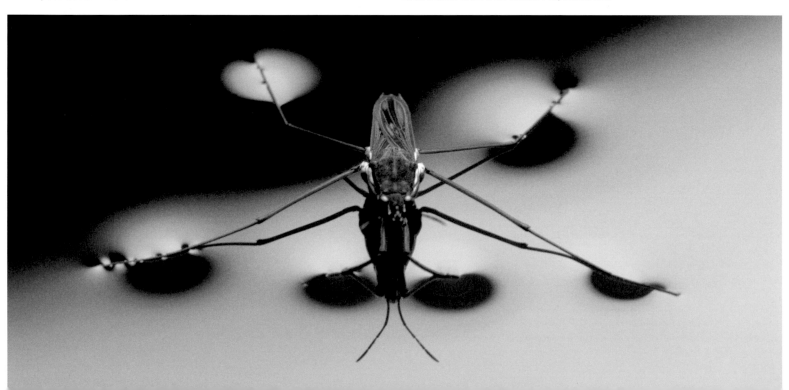

55

Squirrels at work

PHOTO TIP

Squirrels occur all over the Gardens. Look out for them feeding on bird feeders throughout the year; also around oak and sweet chestnut trees when the fruits ripen.

top
A squirrel buries a sweet chestnut. 21 September 2008

middle
A squirrel sits on its haunches to feed at dusk. 2 May 2008

bottom
A squirrel searches for nuts amongst fallen leaves in autumn. 22 November 2008

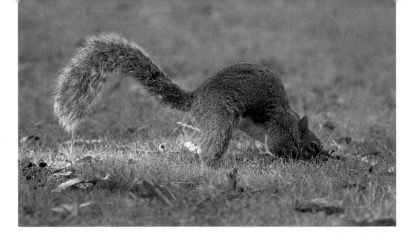

When grey squirrels are disturbed while foraging out in the open early or late in the day, they scamper across lawns making for the nearest tree trunk. These rodents are agile climbers, using their long, double-jointed hind legs and sharp claws to grip the trunk and their tails for balance. They can move at speed upside down along wire lines, and female squirrels can even climb with young in their mouths. The bushy tail is used to signal to one another – a twitching tail conveys an uneasy squirrel. In winter, the tail is wrapped around the body, like a duvet, to keep it warm.

The position of the nest, which is called a drey, varies with the season. Summer dreys are built more out in the open on branches, whereas winter dreys may be inside a tree hole for greater protection and warmth when a deciduous tree is no longer in leaf. Nest building starts in July. Branches form the basic structure and the inside is lined with leaves, grasses and fur.

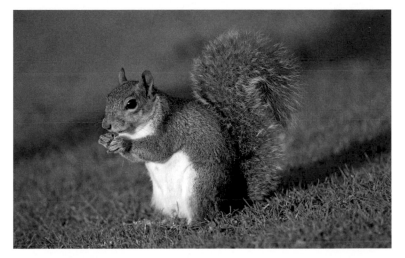

In late December to January, squirrels can be seen chasing one another up trunks and along branches during their courtship. Six weeks after mating, a female gives birth to up to seven (average of three) offspring, which are born blind and naked. They have to be suckled every three or four hours. Some females produce a second litter in the summer, and young squirrels are able to reproduce within a year of birth.

Grey squirrels, which originate from North America, were accidentally and intentionally released to the British countryside from zoos and collections between 1876 and 1929; they are now widespread over most of England and Wales and have become a serious pest in some areas. Their ability to adapt to a wide range of habitats has contributed to the demise of our native red squirrels (*Sciurus vulgaris*). Grey squirrels can do great damage to trees in early summer when they gnaw the bark to reach the sap. On the other hand, they help to disperse tree seeds by collecting and burying acorns, sweet chestnuts, hazel and beech nuts, which they cannot eat. They will also eat bulbs, corms and shoots as well as catkins in spring and fungi in autumn.

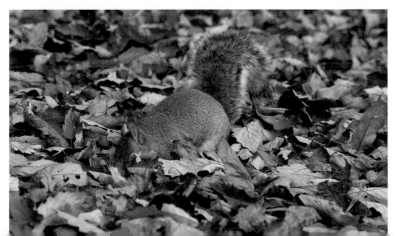

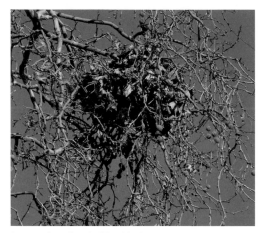

Summer drey of squirrel in mid-winter amongst London plane bobble fruits. 9 January 2009

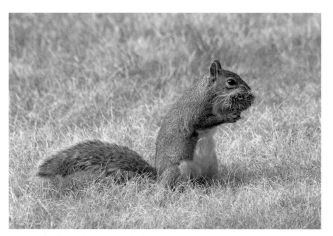

A squirrel collects dry grass at dusk to line its summer drey. 12 July 2008

Early in the morning a squirrel escapes up a tree trunk. 8 June 2008

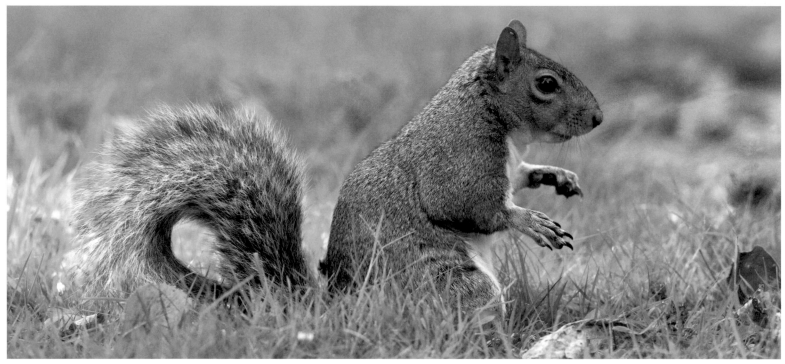

A squirrel pauses whilst foraging at dusk. 7 July 2008

Ragwort foragers

After a cool night wait a few hours after sunrise for insects to become active, then ragwort flowers will be buzzing with activity.

Ragwort flower heads provide a flat landing platform for foraging insects. 15 July 2008

Local names for ragwort (*Senecio jacobaea*) such as stinking billy, mare-fart and staggerwort provide clues to the less favourable features of this widespread weed. This 1.5 metre (five feet) tall biennial, which flourishes in overgrazed areas, has leaves that stink when crushed. Ragwort arouses mixed emotions: farmers and anyone working with horses detest the plant because it is toxic to cattle and especially to horses. Whether eaten as a fresh plant or in hay or silage, alkaloids in ragwort cause cumulative damage to the DNA in the liver of horses, which can be fatal. This plant is one of several injurious weeds specified by Defra.

Yet conservationists and entomologists extol the virtues of this native British plant, which provides food for several hundred insects. Amongst the 30 species dependent on ragwort is the cinnabar moth (*Tyria jacobaeae*). The caterpillars eat the flowers down to the stalk absorbing the plant toxins, which, as their distinct yellow-and-black-banded warning colouration suggests, makes these insects unpleasant to would-be predators.

Ragwort is a biennial or perennial plant that appears as a low leafy rosette in the first year. It is not until the following summer that the flowering stems are produced. The yellow daisy-like flowers of ragwort are arranged in dense clusters known as corymbs. These provide a large, conspicuous landing platform for visiting insects, which can feed by simply crawling from flower to flower, and, on a sunny day, bask in the sun. The flowers are visited by no less than 27 moth species, 22 thrips, 13 bugs, 9 flies and 6 beetles; while the pollen is eaten by bumblebees, solitary bees, droneflies and carrion flies. Ragwort is also host to the parasitic common broomrape (*Orobanche minor*) and to 14 species of fungi. The fact that so many insects depend on ragwort is an argument for controlling the plant when it poses a threat to livestock, since eradication would threaten the many species which depend on it.

A large ragwort plant can produce over 2,000 flower heads in a lifetime. Two types of seeds are formed; those in the centre of the disc have a hairy parachute for wind dispersal, while heavier seeds around the edge are scattered as the plant is shaken in the wind and land nearby.

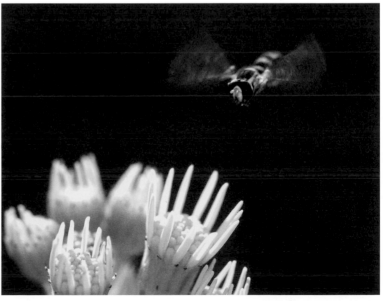

Hoverfly hovers above ragwort. 15 July 2008

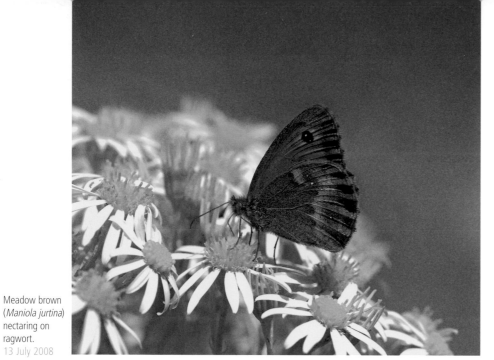

Meadow brown (*Maniola jurtina*) nectaring on ragwort. 13 July 2008

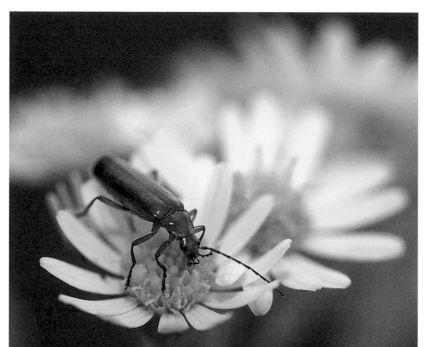

Soldier beetle (*Rhagonycha fulva*) feeds on ragwort. 15 July 2008

Bumblebee forages on ragwort. 13 July 2008

Seven spot ladybird amongst ragwort buds. 13 July 2008

Hoverfly feeds on ragwort. 13 July 2008

Harlequin ladybird or ladybug rests on ragwort flower. 13 July 2008

Grebes
little and large

The Sackler Crossing is a good viewpoint for watching little grebes on either side of the Lake, especially when the birds remain on the surface preening.

top
A great crested grebe with erect crest swims on the Lake at dusk. 4 June 2008

middle
At dusk, a great crested grebe stretches leg and wing on the Lake, with flies on water. 16 June 2008

bottom
A great crested grebe preens its pale belly on the Lake at dusk. 16 June 2008

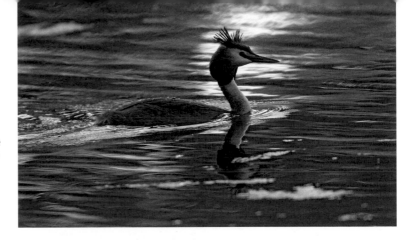

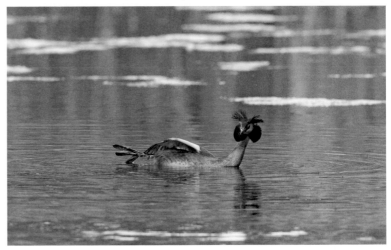

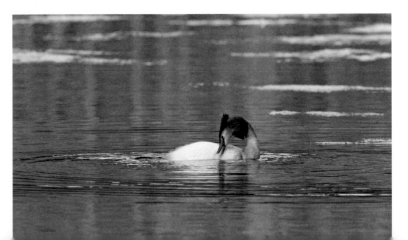

Amongst the many different kinds of water birds that frequent the Lake, two are arguably the most secretive. The little grebe or dabchick (*Tachybaptus ruficollis*) is a small bird with a powder-puff tail created by fluffing up white feathers. In summer it sports a chestnut throat and cheeks. Even though little grebes are more abundant than the larger great crested grebe (*Podiceps cristatus*) they are not always easy to spot because they have a habit of diving when alarmed; often just as one is sighted in binoculars or a camera it disappears, only to surface some way away before invariably repeating the procedure all over again.

Little grebes feed on small fish and dragonfly larvae. They build a floating nest made from rotting aquatic plants which generate heat and help to speed up incubation. Young chicks are carried around under the wings and when an adult dives they pop up to the surface like corks.

The elegant great crested grebe is the largest European grebe and it also dives as an escape route in preference to flying. This grebe has thickly-lobed feet placed far back on the body, which is an advantage for chasing fish prey underwater but makes for clumsy walking on land. The pronounced head plumes are raised during the elaborate courtship display which culminates with both birds diving to collect weeds, rising up to face each other and shaking their head plumes. The stripy chicks, which are often carried on the back, can swim and dive almost as soon as they hatch.

During the Victorian era, great crested grebes were hunted almost to extinction for their head plumes, which were used for decorating hats, and their breast plumage – known as 'grebe fur' – was used as a fur substitute. In 1889, a group of women, known as 'Fur, Fin and Feather Folk', protested against the grebe slaughter and promised to refrain from wearing the feathers of any birds not killed for food, apart from the ostrich. By 1890 they had attracted over 5,000 members and by 1904 became known as the Royal Society for the Protection of Birds (the RSPB).

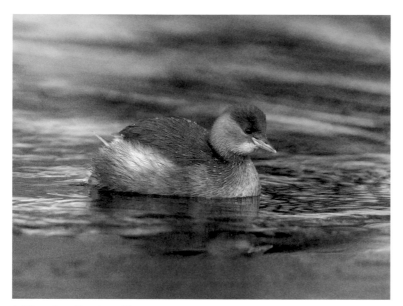

A little grebe, with autumnal leaves reflected in the water. 9 January 2009

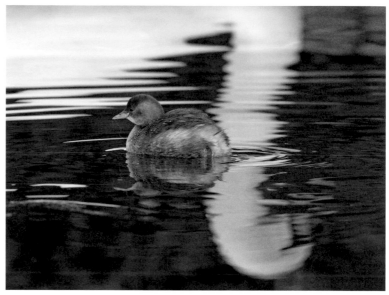

A little grebe swims past the reflection of a mute swan. 7 January 2009

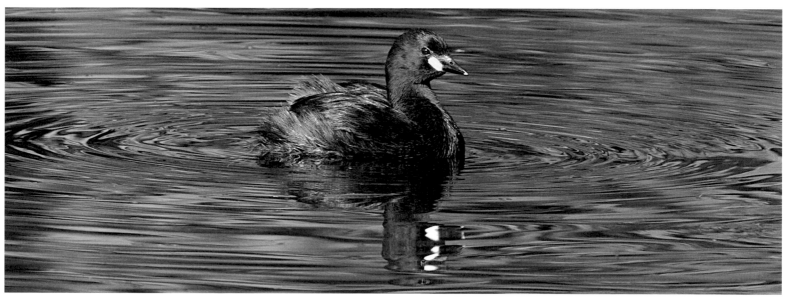

An adult little grebe or dabchick on the Lake in summer with lakeside trees reflected in the water. 5 June 2008

Stag nights

PHOTO TIP

Stag beetles are most likely to be seen late in the day and a good place is the Stag Beetle Loggery in the Conservation Area.

Britain's largest ground-living beetle – the stag beetle (*Lucanus cervus*) – is now quite rare, but can be found in south and south-east England, with the Thames Valley being one of the few remaining hotspots. Male stag beetles can be seen in flight just before dusk on warm summer nights from mid-May until late July, when they are attracted to lighted windows. The seven centimetres (2.75 inches) long male has a huge pair of jaws not unlike deer antlers, hence the common name. They are used in territorial fights as one male grabs another and attempts to throw it. Female jaws, on the other hand, are small although quite powerful.

Female stag beetles rarely fly; they attract males by releasing pheromones (sex scents). After mating the females seek out dead wood, such as old stumps or fallen trunks of broadleaved deciduous trees, to lay their eggs and then die. The eggs hatch out into white grub-like larvae that munch their way through large quantities of decaying wood, helping to recycle organic matter back into the environment. Some five years after the eggs are laid adult beetles finally emerge from the pupal stage. They do not eat, but will drink the sap of trees.

Tidying up woodlands, parks and gardens by removing dead and decaying trees reduces suitable breeding sites not only for stag beetles but also for some other rare beetles as well as nesting sites for birds and bats and a series of microhabitats for fungi, mosses and lichens. Within the UK, decaying wood is home to a staggering number of insect species, approaching 1,800.

Ways to enhance the breeding success of stag beetles is to provide more places for females to breed. This can be done by making a log pile in the corner of a garden or by burying a plastic bucket with drainage holes in the sides and bottom. After placing stones in the bottom, fill the bucket with a 1:3 mixture of soil and woodchips (preferably hardwood) before burying in the ground. As the wood rots down it will need to be topped up periodically and left for a five year period.

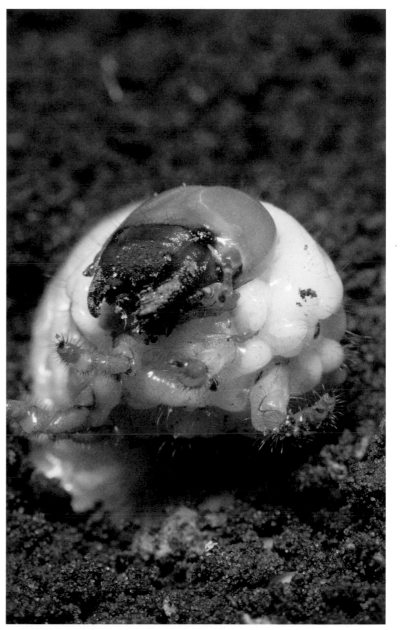

The grub-like stag beetle larva has an orange head and uses the dark jaws to feed on rotting wood. 2 December 2007

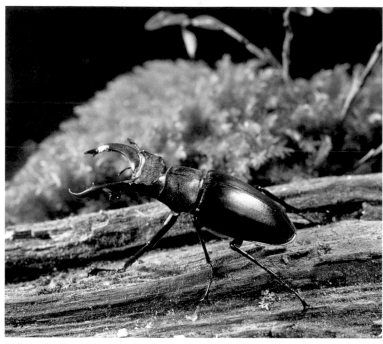

Male stag beetle with its outsized
mandibles. 18 May 2007

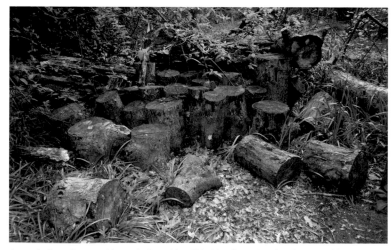

A wood pile at Kew provides a shady and humid habitat for various beetles – notably
stag beetles – as well as centipedes, fungi, mosses and over-wintering amphibians.

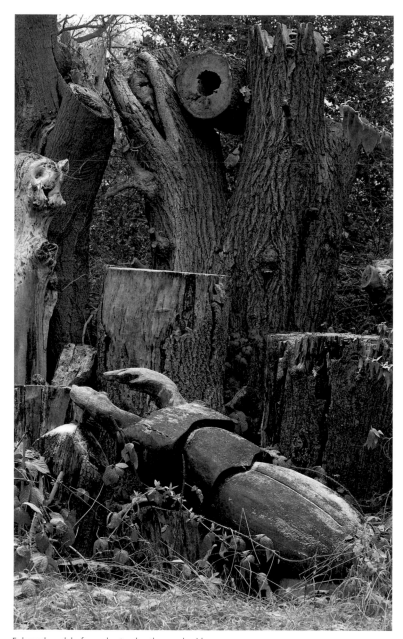

Enlarged model of a male stag beetle seen beside
the Stag Beetle Loggery. 10 January 2009

63

The longest day

The aim was to make a photo diary of Kew wildlife throughout the day and into the evening. The idyllic summer's day I had visualised turned out to be wet and overcast. Even so, with some 15 hours of daylight, I could afford to spend time lingering in search of less obvious macro subjects.

21 June 2008

04:41 Sunrise
21:22 Sunset

06:00 Arrived at Jodrell Gate in persistent drizzle, checked out the British plants section in the Rock Garden.

06:34 Mountain avens (*Dryas octopetala*) seedhead with raindrops.

06:58 Rain on spider's web on bearberry (*Arctostaphylos uva-ursi*). Light drizzle is perfect weather for spotting and photographing webs.

07:17 A mallard drake snoozes on rim of ornamental pond in the Duke's Garden.

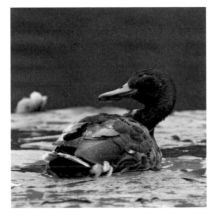

07:48 A mallard drake preens on Sir Joseph Banks Building Pond with brandy bottle or yellow water lily (*Nuphar lutea*) flowers.

09:07 Raindrops on fennel (*Foeniculum* sp.) in the Queen's Garden function as miniature fish-eye lenses showing an inverted Kew Palace – the most exciting shot of the day.

09:15 Rain stops.

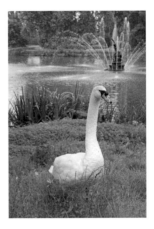

10:12 A swan beside Palm House Pond with fountain playing.

10:19 A mallard feeds on grass seeds beside Palm House Pond.

11:24 Bar-headed geese feed on land with goslings.

12:04 A large group of Canada geese races towards visitors with food.

12:09 Young Canada geese graze alongside parents.

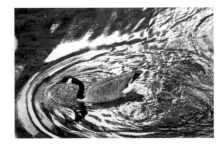

12:16 Canada geese family takes to water.

12:33 Canada geese goslings rest on land.

12:57 A mute swan bathes in the Lake by pushing its neck and upper body underwater, so that the water flows back down its body after surfacing.

13:15 At the west end of the Lake male flowers of greater reedmace or bulrush (*Typha latifolia*) first caught my eye, followed by damselflies flitting around and amber snails (*Succinea putris*) crawling over stems and leaves.

14:06 A closer look at the ragged leaf margins of yellow flag soon revealed the culprits: iris sawfly larvae (*Rhadinoceraea micans*). These larvae attack and defoliate leaves of any irises that grow beside ponds, lakes and canals.

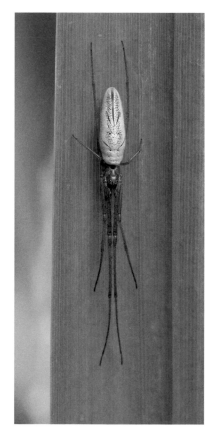

14:36 Yellow-bodied rush spider (*Tetragnatha extensa*) rests on yellow flag leaf with the slender elongated legs at full stretch.

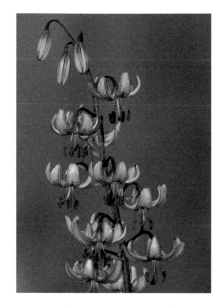

16:36 Martagon lilies *(Lilium martagon)* flower in the Conservation Area.

18:48 A mute swan near its nest at the edge of the Palm House Pond.

19:28 A mute swan with cygnets beside the Palm House Pond. Swans and cygnets feed on grass beside their nest.

19:52 A heron gains an elevated fishing viewpoint on a branch above the Sir Joseph Banks Building Pond.

20:07 A moorhen sits on its nest made from reeds, alder (*Alnus glutinosa*) branches and discarded paper on the Sir Joseph Banks Building Pond.

21:00 Left via Jodrell Gate at the end of a completely overcast day.

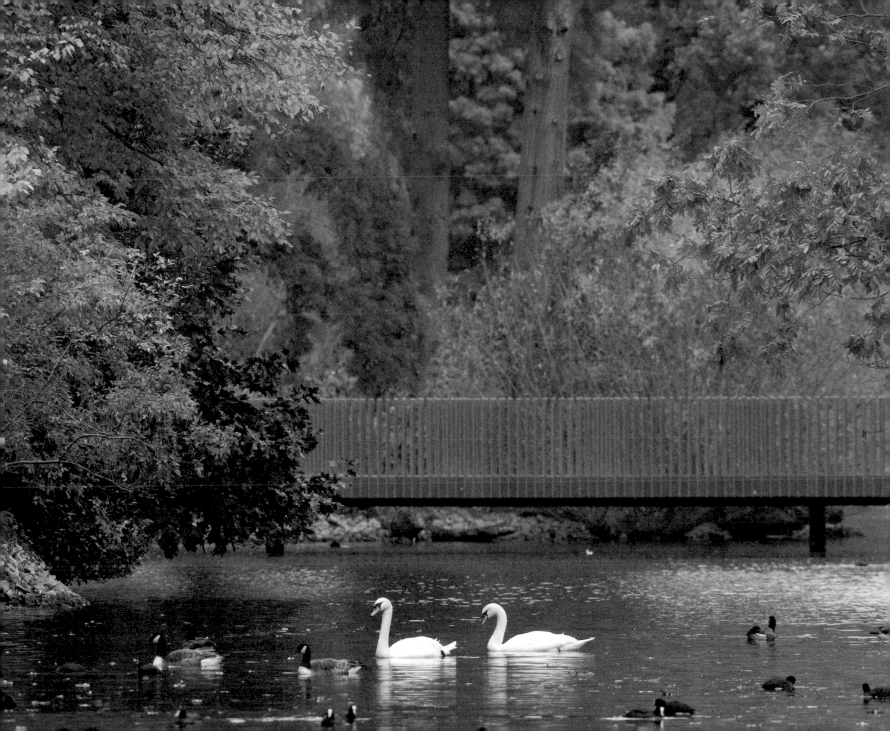

AUTUMN

In some years, autumn can be one of the most glorious of all the seasons, when optimum weather conditions produce vibrant autumn colours that persist through calm windless days. On warm sunny days, butterflies and dragonflies can be seen on the wing visiting late summer flowers or hawking over water respectively. As the days shorten and the temperature begins to drop – especially at night – the last blooms of summer fade, having invested their energy in seed production, and perennials commit their food reserves to underground bulbs, rhizomes or tubers.

The abundance of fruits produced by shrubs and trees in autumn relates to the weather at the time the flowers appear, since insect pollinators need good weather to be able to fly and forage. Successful wind-pollination also depends on fine weather for the pollen clouds from pine and yew trees to be wafted onto the female flowers. As flowers fade and leaves wither, a galaxy of ephemeral fungi begins to appear all over the Gardens in lawns, on beds and also on trees.

Unlike spring, where there is a long-established tradition of recording the first date when a wild flower appears or the first cuckoo is heard, recording autumnal events is a much more recent activity. Spurred on by the annual BBC coverage, Autumnwatch recorders are encouraged to submit their records of when fruits ripen, leaves turn colour or begin to fall, which helps to expand the nationwide data. From this we know that ripe blackberry fruits are now found on average as early as 5 August. In good mast years when acorns and chestnuts are plentiful, birds and mammals which feast on them don't have to expend much time or energy feeding.

left

Wildfowl – mute swans, Canada geese and coots – swim on the Lake past autumn tints near the Sackler Crossing. 1 November 2008

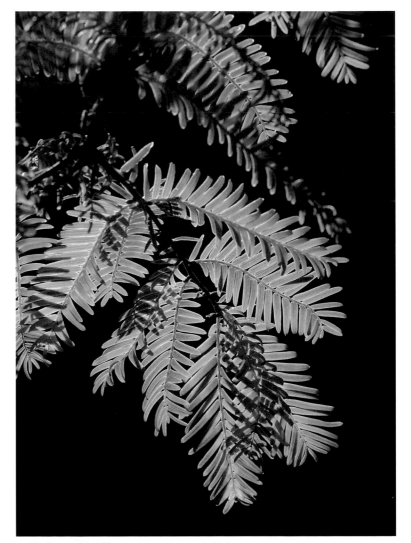

Backlit dawn redwood (*Metasequoia glyptostroboides*) leaves beside the Lake. 18 October 2008

Yet autumn colours and leaf fall are gradually getting later; for example, oak leaves are not falling until the end of October, which is a week later than three decades ago. Weather undoubtedly plays a part in the timing and intensity of autumn colour. Recent research has discovered that the presence of elevated carbon dioxide levels (as occurs with global warming) enables carbon-rich compounds to be produced, which prolongs the life of green leaves.

Autumn is the season when many of nature's activities begin to wind down. Animals which have bred successfully and finished rearing their offspring only have to find enough food to nourish themselves, but they make sure to feast on bountiful fruits to build up their bodies ready for the bleakest season of them all – winter. Some birds and squirrels will take advantage of a bumper autumn crop, spending time collecting and caching surplus food by burying it in the ground to utilise during cold winter spells. Not all of this larder is retrieved, but the hoarding instincts of these animals help to disperse heavy fruits such as acorns and chestnuts away from the parent tree.

For much of the year many trees barely get a second glance, but when sunny autumn days coincide with spectacular vivid yellow or red leaves, viewed against a blue sky, they provide irresistible photographic subjects. Arguably even more evocative are the moody, misty mornings when sun beams through the trees to spotlight the ground.

far right

A male yellow golden pheasant strides through fallen maidenhair tree (*Ginkgo biloba*) leaves. 1 November 2008

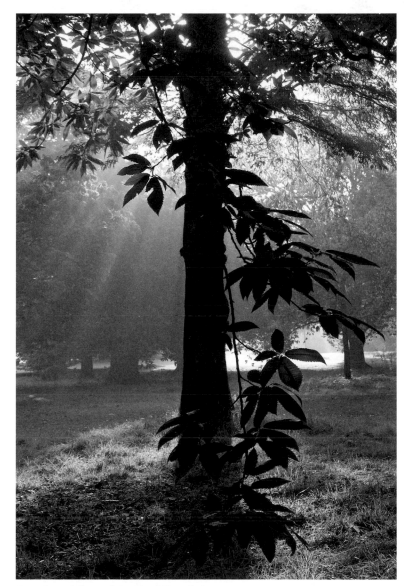

On a misty morning, sunbeams break through the tree canopy behind a sweet chestnut. 21 September 2008

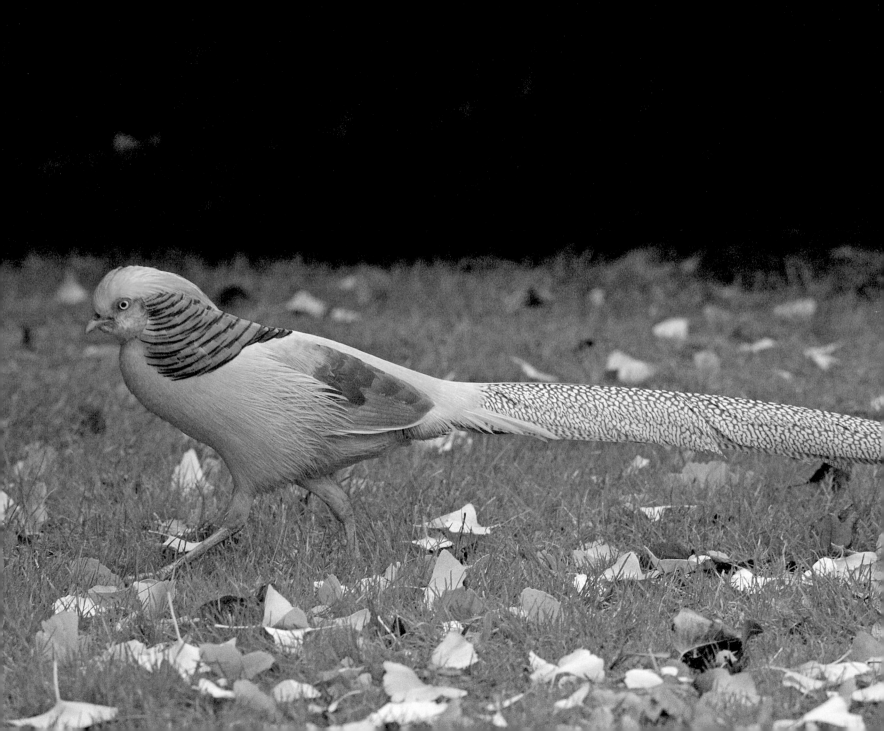

Late bloomers

Choose a sunny day to search for insects feeding on late summer flowers; avoid sudden jerky movements which scare off insects.

Autumn crocus flowers track the sun several months after the leaves are produced in spring.
27 September 2008

Long after spring and summer flowers have faded and set seed, a few flowers come into their prime and provide invaluable nectar or pollen sources for insects still on the wing. This helps hibernating insects to be better prepared for the winter and therefore more likely to survive until they can resume foraging in the following spring.

Many old fashioned cottage garden flowers such as dahlias and Michaelmas daisies attract butterflies, as do many native British flowers, such as mints and other herbs. Double-flowered cultivars, on the other hand, are invariably sterile and therefore do not secrete nectar or produce pollen and so fail to attract insects.

Notable autumn flowers favoured by insects are ivy flowers (see page 74); the flat pink heads of the ice plant (*Sedum spectabile)* which provide a useful foraging platform for bees, flies and butterflies; autumn crocus (*Colchicum autumnale*); the purple coneflower (*Echinacea purpurea*) and exotic salvias. Spectacular planting of autumn crocus corms around hollies in the Holly Walk, leading to the entrance of the Xstrata Treetop Walkway path, produce drifts of colour in late September and early October. On sunny days when the petals unfurl to expose the floral parts, bees and hoverflies busily forage on flowers that turn to face the sun.

Many salvias native to South America bring vivid colours – deep blues, purples and carmine – to an autumnal garden, as well as providing valuable nectar and pollen late in the year. Several can be seen along the west facing wall that borders the east side of the Rock Garden, where they will continue flowering through to November if there are no frosts. Both honeybees and bumblebees forage on the deep blue flowers of the Bolivian *Salvia atrocyanea*; whereas wasps select older flowers that have shed the blue corolla tube and crawl inside the deep-throated green calyces.

One of the delights of a late summer and early autumn evening is to watch evening primrose (*Oenothera biennis*) flowers open at dusk. After the sepals split, they fall away from the petals which unfurl by twisting and opening outwards ready to receive their nocturnal moth pollinators.

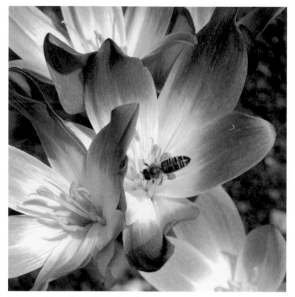

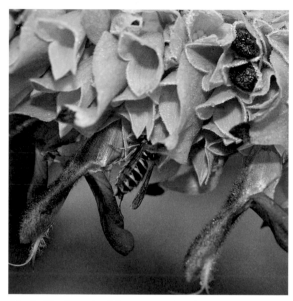

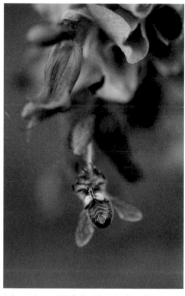

Dusted with pollen, a honeybee forages on autumn crocus. 27 September 2008

After the blue flower has fallen, a wasp enters the green calyx of *Salvia atrocyanea* to feed. 11 October 2008

A honeybee with full pollen baskets forages on *Salvia atrocyanea*. 11 October 2008

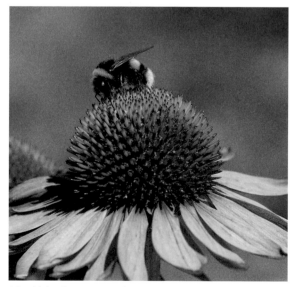

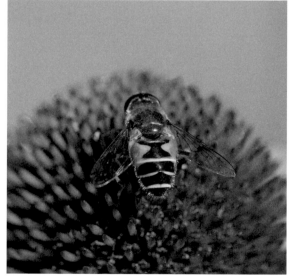

A honeybee robs nectar from the back of an autumn crocus flower. 27 September 2008

A bumblebee forages on purple coneflower. 4 August 2007

A hoverfly forages on purple coneflower. 4 August 2007

Damsels and dragons

PHOTO TIP

As a dragonfly zips to and fro near water, note where it eventually settles. Prefocus the camera on this spot, as if it has flown away it will invariably return here.

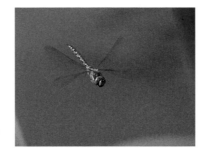

A common hawker (*Aeshna juncea*) hovers at the edge of the Lake. 21 September 2008

One of the glories of a summer's day is to watch a dragonfly flitting back and forth within its territory or alighting on a branch to bask in the sun or feed on an insect caught in mid air. Dragonflies can be seen on the wing on sunny days from May to October, but with different emergence times for each species, they are not all on the wing together.

Dragonflies are much larger than damselflies and when they come to rest their wings are displayed at right angles to the body; whereas damselflies fold their wings back against their slender bodies when they rest. The Aquatic Garden, the Waterlily Pond and the Lake are all rewarding places to see both dragonflies and damselflies. The raised wall of the waterlily pool in the Aquatic Garden allows a closer approach to the water than either the Lake or the Waterlily Pond.

Nine species of dragonflies are known to breed at Kew and one of the first to emerge is the broad-bodied chaser (*Libellula depressa*) in late May. The hawkers live up to their name, hawking to and fro within their territory chasing off intruders. Dragonflies catch food on the wing and then alight to feed – often on a favourite branch or reed. They also bask on rocks around the Lake and the raised wall of the Aquatic Garden and even on the waterlily labels there. Sometimes they can be seen flying around or resting on vegetation with a male and female in tandem; after they separate, a female may be seen ovipositing (laying eggs) in water. A nymph hatches from each egg and lives a completely aquatic existence for several years, moulting repeatedly before it crawls out of water so the dragonfly can emerge.

In recent years, five species of damselflies have been breeding at Kew. They are easiest to spot when perching on plants near water; try looking beside the Waterlily Pond or at the end of the Lake nearest the Thames. According to the British Dragonfly Society, more than one third of Britain's dragonflies are under threat from habitat loss, pollution or climate change.

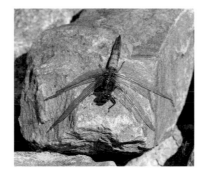

A black-tailed skimmer (*Orthetrum cancellatum*) sunbathes on a rock beside the Lake. 13 July 2008

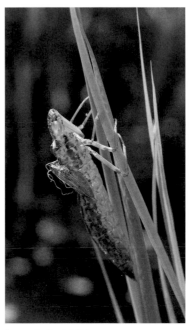

An empty shuck left by a dragonfly after emergence from the Aquatic Garden. 9 June 2008

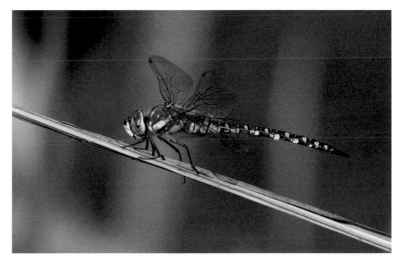

A common hawker perches on a leaf at the edge of the Lake. 21 September 2008

right

An azure damselfly (*Coenagrion puella*) rests on a daylily beside the Waterlily Pond. 8 June 2008

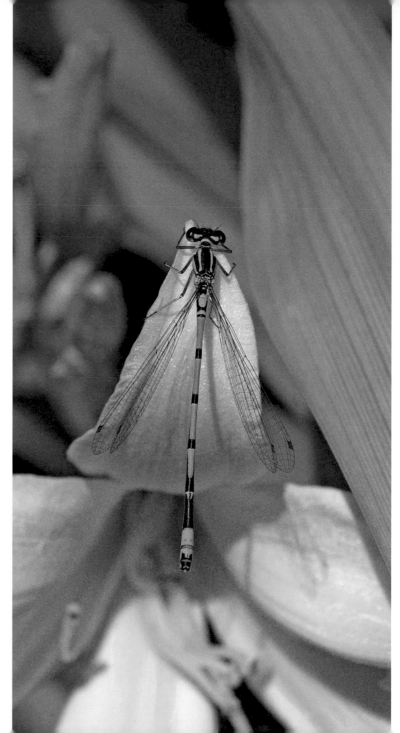

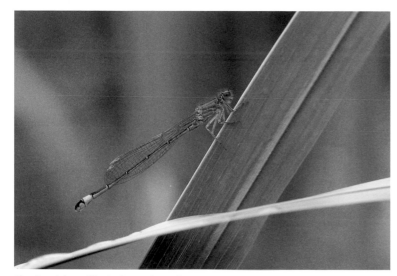

Blue-ringed damselflies (*Ischnura elegans* f. *rufescens*) can be found at the west end of the Lake flitting over stems and leaves. 21 June 2008

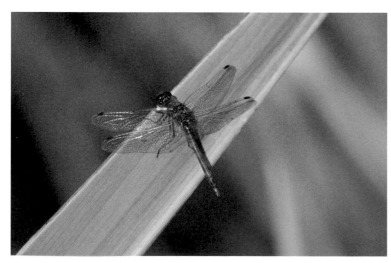

A common darter (*Sympetrum striolatum*) basks in the late afternoon sun. 21 September 2008

Lively ivy

Ivies – the evergreen woody climbers that scramble up trees in the wild and their many cultivars – produce clusters of insignificant yellowish-green flowers. Understated they may be, yet these flowers provide an invaluable autumn food source for insects. Flies, hoverflies and bees forage on the yellow pollen produced by the erect stamens, while beetles, hornets, wasps and butterflies feed on the nectar. Ivy is also a vital food source for the butterflies which hibernate overwinter as adults.

On a warm sunny day the flowers are buzzing with insects. On one morning at Kew there were several species of flies, hoverflies, a few honeybees and bumblebees, plus a couple of hornets (*Vespa crabro*), a rose chafer (*Cetonia aurata*) and a red admiral (*Vanessa atalanta*) – all aiding pollination as they buried their heads into ivy flowers to feed. A little later in autumn, wasps and comma butterflies (*Polygonia c-album*) were seen to be foraging on a later flowering ivy. The pollen gatherers approach the flower from in front so they reach the upright stamens first. Nectar gatherers, on the other hand, tend to land on leaves and crawl around accessing the flower cluster from below.

Yellow and brown hornets will not tolerate another hornet on their patch, so mid-air fights are frequently witnessed. Hornets feed on sugary foods including nectar and fruits. They also capture insects, immobilising them with their sting before chewing them up to regurgitate to their larvae inside a papery nest. In return, during wet weather when the workers cannot forage, the larvae feed them a sugary solution.

Compared to wasps, the large size of hornets can be alarming; but in fact, hornets should be encouraged since they help to keep not only garden insect pests but also houseflies in check. Attracted to light, hornets have been known to crash into a lighted window at night. A warmer climate resulting from global warming has seen an increase in numbers of these insects, which were a rare sight in Britain a few decades ago but are now establishing themselves, especially in the south.

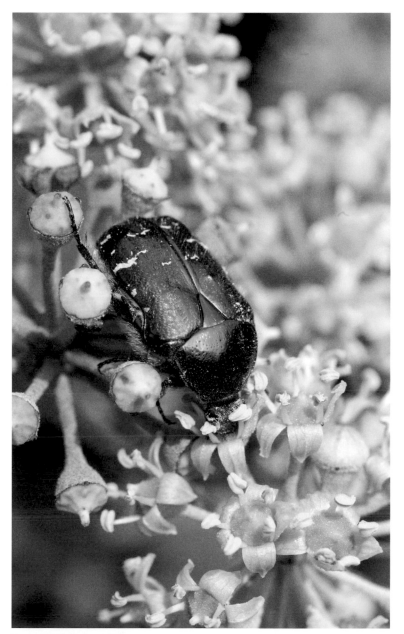

The rose chafer has metallic green wing cases. 30 August 2008

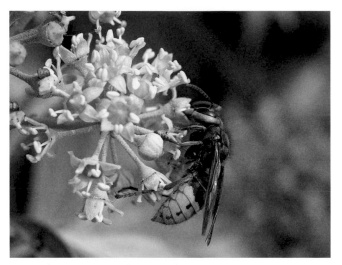

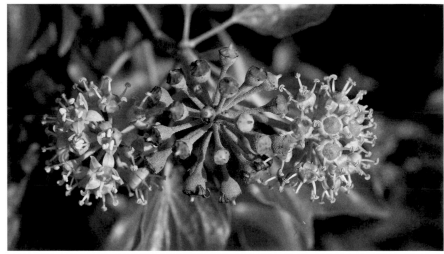

A hornet feeds on nectar produced by ivy flowers. 30 August 2008

Clusters of ivy flowers appear in autumn. 30 August 2008

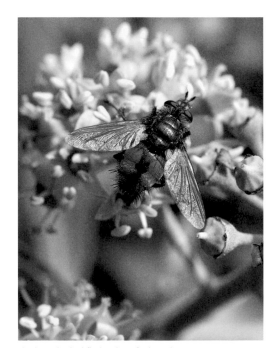

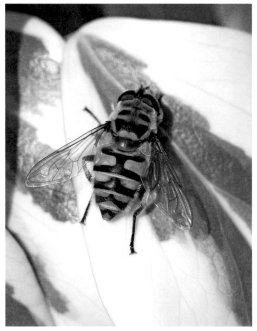

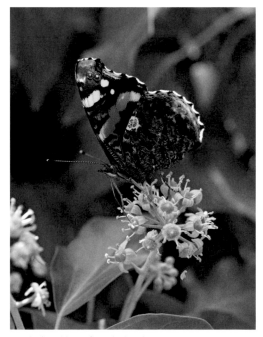

The hairy-bodied fly (*Tachina fera*) produces parasitic larvae which attack caterpillars. 30 August 2008

The hoverfly *Myathropa florea* sunbathes on a variegated Persian ivy (*Hedera colchica* 'Dentata Variegata') leaf. 30 August 2008

A red admiral butterfly with closed wings feeds on ivy flowers. 30 August 2008

The Treetop Walkway

Supports and part of the stairway up to the 18 metre (59 feet) high Xstrata Treetop Walkway which weaves through the tree canopy in the Arboretum. 24 May 2008

After a temporary scaffolding skywalk was erected at Kew in 2003, it was decided to build a permanent structure. In May 2008 – Kew Gardens' Year of the Tree – the Rhizotron and Xstrata Treetop Walkway was opened. Designed by Marks Barfield Architects, who created the London Eye, and built from the same rusted weathering steel as the Angel of the North, the 200-metre-long walkway is raised 18 metres (59 feet) up above the ground with handrails carved from coppiced sweet chestnuts in Sussex and Kent. It provides a bird's eye view looking across towards the Temperate House in one direction and as far as the London Eye in another. In winter, when the trees are bare, Canary Wharf and the Gherkin building can be seen, and Wembley Stadium is visible throughout the year.

Here is a rare chance to appreciate trees within Kew's Arboretum from a new perspective by walking through their upper canopies. Views from the walkway vary with the seasons as the adjacent deciduous trees change dramatically when they begin to leaf out in spring, turn colour in autumn and drop their leaves at the onset of winter.

Oaks (*Quercus* spp.) can be seen flowering (and fruiting) at eye level instead of by a craning neck from the ground. Birds, too, can be seen skimming over the tree tops or foraging on fruiting trees. It did not take long for ring-necked parakeets (*Psittacula krameri*) to discover an easy way to breakfast was to take advantage of sweet chestnut fruits that fall overnight onto the walkway, before being cleared away by Kew staff. They will also drink dew or rain water from the handrails by tilting their heads to one side so they can suck it up through the broad side of their bill.

Even insects which we see down on the ground, including butterflies and hornets, are active at this elevated height. Tree-creepers, woodpeckers, nuthatches, tawny owls, jays and magpies are just some of the other birds which may be seen at close range from the walkway.

Red oak (*Quercus rubra*) leafing out with catkins in the rain. 17 April 2009

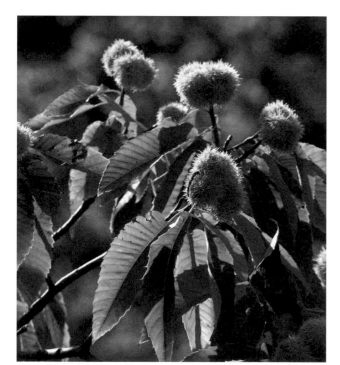

Spiky husked fruits of sweet chestnut seen from the Xstrata Treetop Walkway. 9 October 2008

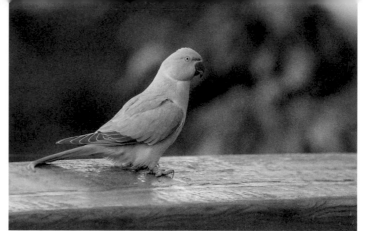

A ring-necked parakeet perches on the handrail of the Xstrata Treetop Walkway early in the morning.
18 October 2008

Part of the Temperate House and the Evolution House from the Xstrata Treetop Walkway on the first day it was open to the public.
24 May 2008

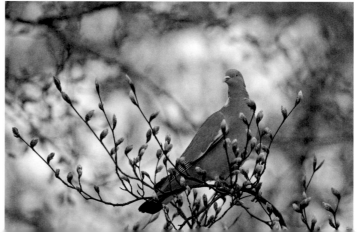

A wood pigeon amongst breaking beech buds – one of many trees that provide these birds with a spring food source. 17 April 2009

Pond watching

A good place to watch freshwater life is the Aquatic Garden where the raised walls contain the water at a much higher level than either in the Waterlily Pond or the Lake. The backswimmer or water boatman (*Notonecta glauca*) is an aquatic bug with beady eyes that hangs from the surface film. Underwater, backswimmers look silvery from the air trapped by a layer of bristles on the underside.

A water boatman homes in towards pressure waves created when a hapless insect falls into the pond or small fish and tadpoles swim underwater, initially using sensory hairs and then vision. Once the prey is grasped by the two pairs of small front legs, it is pierced by the sharply pointed rostrum or beak and poisonous saliva is injected so the body fluid can be sucked out. Water boatmen feed more frequently at night when the temperature drops and more oxygen is dissolved in the water allowing dives to be deeper and last longer.

On warm days, smooth or common newts (*Lissotriton vulgaris*) may move up to bask on green filamentous blanketweed under the surface but, being nocturnal, many more appear at the surface at night. Adults, as well as juveniles, hibernate out of water during winter, seeking out moist places beneath stones or logs. In February or March they break their hibernation and crawl to a breeding site. After an elaborate courtship display the female wraps leaves around each egg she lays. The young larvae which hatch have conspicuous feathery external gills.

Many visitors to Kew are surprised when they spot Chinese mitten crabs (*Eriocheir sinensis*) in the Lake or crawling on land in the autumn. They have a rounded shell or carapace and the male crabs have a mass of soft bristles resembling mittens on their pincers. These crabs have lived in the Thames for years and probably entered the Lake as larvae in Thames water, which is used to top up the Lake at high tide. Originating from the Far East, these crabs have become invasive in Europe and are now on the IUCN list of 100 worst invasive alien species. It is thought they reached British shores via ballast water in shipping.

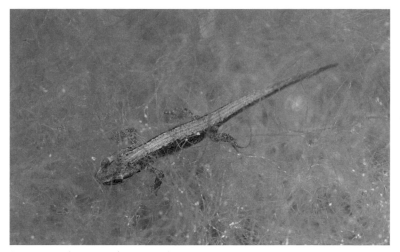

A young smooth newt crawls amongst alga in the Aquatic Garden. 30 September 2008

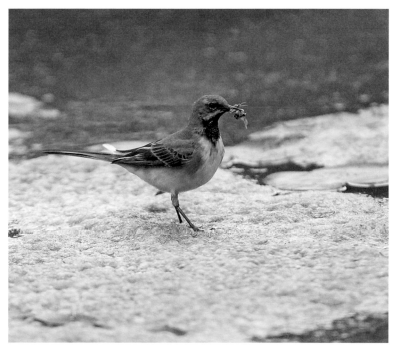

When an algal mat covered the surface of the Aquatic Garden, a grey wagtail (*Motacilla cinerea*) was able to walk on water to catch emerging aquatic insects to feed its chicks. 21 May 2008

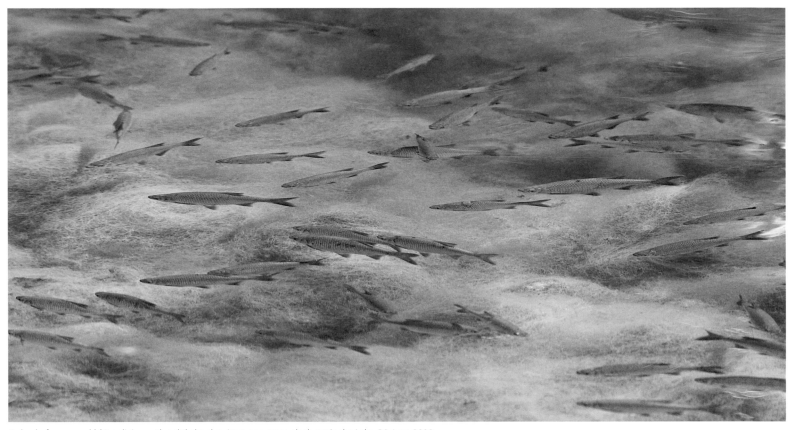

A shoal of young rudd (*Scardinius erythrophthalmus*) swim over a green algal mat in the Lake. 30 June 2008

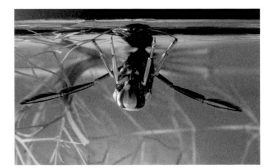

A water boatman or backswimmer surfaces to breathe. 5 April 2008

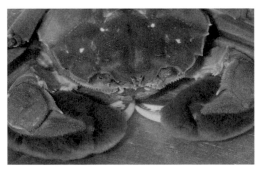

A male Chinese mitten crab shows how the bristles around the base of the claws resemble mittens. (Taken in China)

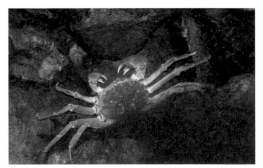

A Chinese mitten crab submerged in the Lake. These crabs threaten river banks by burrowing and causing them to be undermined. 21 September 2008

An eventful afternoon

Any visit to Kew will guarantee to produce wildlife sightings, but on rare occasions a sequence of exceptional events may be witnessed in a matter of minutes. On a fine Saturday September afternoon the Gardens were packed with visitors, some of whom saw a spectacular saga unfold on the Palm House Pond. There are not many places where cormorants (*Phalacrocorax carbo*) can dry their wings mid water in this pond. Earlier in the year they used a moorhen's nest but after it disintegrated they resorted to climbing onto the base of a water fountain jet in the centre of the Pond, as one had that afternoon.

Herons normally fish early or late in the day, but they are opportunist predators which never miss the chance of an unexpected meal – at anytime of day. As a heron flew in towards the submerged base of the fountain with a large duckling grasped by its tail, the cormorant speedily departed. With the live duckling frantically flapping its wings and kicking its feet, the heron repeatedly dunked it in the water attempting to drown the bird. At one stage the heron let go of the prey to grasp it by the bill so it could eventually swallow it head first and avoid the wings getting stuck in its throat. While all this was going on, Canada geese and other birds on the pond swam over towards the heron to investigate the drama, forming a semi-circle around the predator. After the onlookers dispersed, the cormorants swam up towards the heron, making a half-hearted attempt at dislodging it, but then thought better of it.

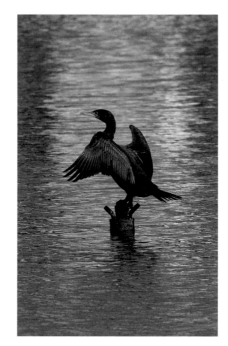

13:05 A cormorant climbs onto fountain to dry its wings.

13:09 A second cormorant displaces the original bird...

13:10 ...and extends its wings to dry them.

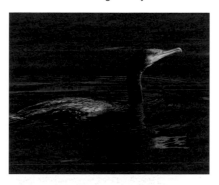

13:11 The first cormorant swims off to fish.

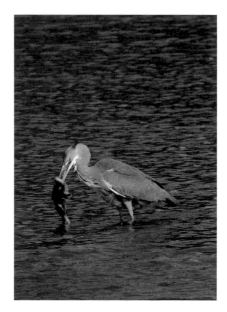

13:13 A heron with a large duckling held by the tail lands on the fountain base displacing the second cormorant.

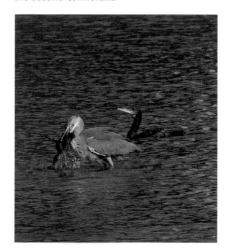

The heron dunks the duckling as a cormorant swims past.

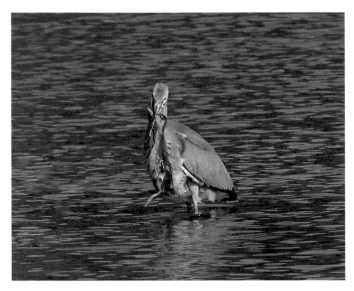

13:14 The heron releases the live duckling to grasp it by the bill and swallow it head first.

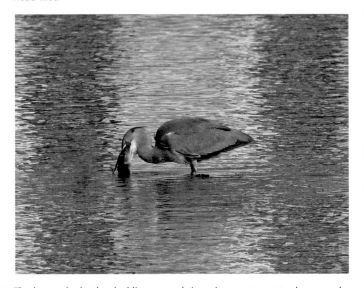

13:15 - The heron dunks the duckling several times in an attempt to drown and
13:18 moisten it.

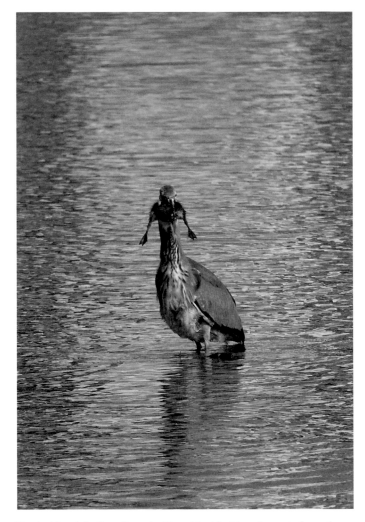

13:19 The duckling is half swallowed with webbed feet hanging out of mouth.

13:20 The duckling is completely swallowed. The heron flies off to land on the bank beside the Pond.

The total time from the first shot to when the duckling was completely swallowed was just over six minutes. 13 September 2008

Fungus forays

Autumn is the prime season for finding larger fungi, although some do appear at other times of year. Unlike plants, fungi have no chlorophyll, the pigment which not only makes plants green but also enables them to produce carbohydrates from carbon dioxide and water in the presence of sunlight. Fungi gain their nourishment by feeding either as saprotrophs on the remains of living organisms – notably rotting wood – or as parasites on living plants or animals.

Fungi are present year round, although for most of the time they exist as a network of fine branching threads – known as mycelium – underground, inside wood and other decaying organic matter or in living plants. The black bootlace-like strands or rhizomorphs of the honey fungus (*Armillaria mellea*) are a conspicuous example of a fungal network. Autumn rains will trigger the development of fruiting bodies which appear above ground a few days later.

Fungi may be solitary, gregarious or grow in tufts and they appear in an array of shapes and colours. Many are typical toadstools, but there are also brackets, clubs, jellies, and even stars. Most are annual and have a relatively short life but some brackets are woody and occur on trees throughout the year with a new spore-producing layer formed each season. The function of the fruiting bodies is to produce a myriad of microscopic spores that are dispersed by wind and will germinate to form a new mycelium if conditions are favourable.

Each fungus is associated with a particular habitat and within the favoured habitat they may depend on a limited range of plants – some fungi just with a single species or genus. For example, the red and white spotted fly agaric (*Amanita muscaria*) forms an association with the roots of birches (*Betula* spp.) and pines (*Pinus* spp.), very rarely with other species. The great variety of trees and shrubs grown at Kew support an abundance of fungi, with as many as several hundred different kinds recorded in a good year. Once ground frosts occur, few fungi appear.

Squirrels will vary their autumnal diet by collecting and eating the occasional fungus. Slime trails on partially chewed fungi provide evidence that slugs or snails have enjoyed a nocturnal feast.

Black bulgar or rubber buttons (*Bulgaria inquinans*) growing on a log lining a path. 12 September 2008

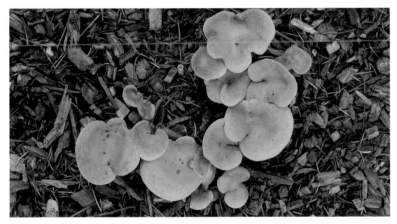

False chanterelles (*Hygrophoropsis aurantiaca*) growing on wood chippings beneath blue Atlas cedar (*Cedrus atlantica* 'Glauca'). 11 September 2008

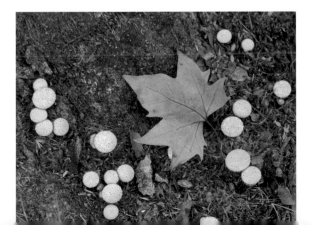

Puff balls (*Lycoperdon pyriforme*) growing around the base of a London plane tree. 12 September 2008

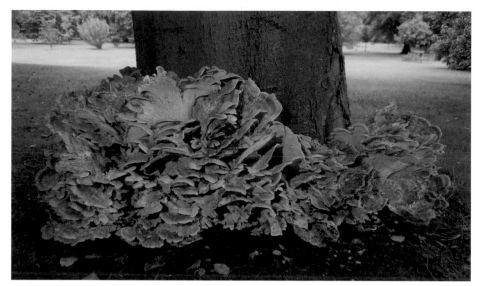

Brackets of the giant polypore (*Meripilus giganteus*) growing from the roots of a common beech tree. 12 September 2008

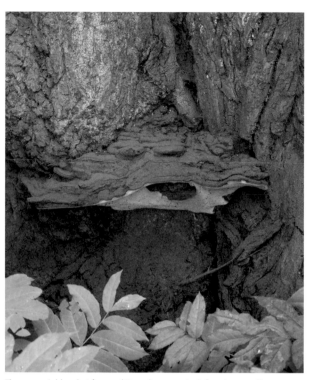

The perennial bracket fungus (*Ganoderma australe* [=*adspersum*]) grows on Caucasian wingnut (*Pterocarya fraxinifolia*) in Syon Vista and produces cocoa-coloured spores. 27 September 2008

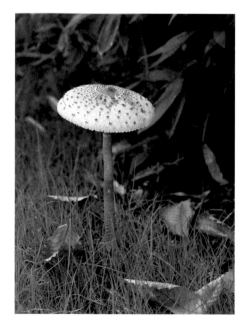

Parasol mushroom (*Macrolepiota procera*) grows in grass beside bamboo. 12 September 2008

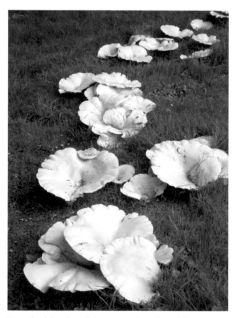

Part of a fairy ring of the cream giant funnel fungus (*Leucopaxillus giganteus*). 12 September 2008

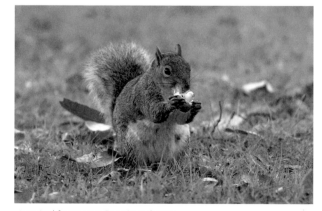

A squirrel feasts on a *Russula* sp. fungus in Syon Vista. 21 September 2008

Wasps and hornets

Wasps and hornets are renowned for getting a bad press: certainly wasps can be a nuisance during a summer picnic, but like hornets they help to reduce insect pests and aid pollination when they visit flowers. Wasps are black and yellow and just over half the size of the brown and yellow hornets, which are the largest British wasp. Unlike honeybees, neither wasps nor hornets store food over winter, so at the end of autumn they all die, apart from the young mated queens which hibernate and emerge on a warm day in late spring.

The large size and noisy flight of hornets make them much feared; but like wasps, they don't attack out of the blue, because they use their sting repeatedly to kill their prey. However, if their flight path is blocked or their nest is vibrated, they will attack.

Both are social insects which construct paper nests by scraping wood from trees or wooden objects and then chewing it with saliva to form a pulp. Wasps nest in old animal burrows or in the roofs of houses, whereas hornets nest in hollow trees or roof spaces. After she has found a suitable nest site, the queen builds a small paper nest so she can begin to lay eggs. These hatch into sterile workers and they then continue building the nest and feeding the larvae. Then all the queen has to do is lay eggs; those laid in late summer develop into male drones and fertile females which become the next generation queens.

Wasps feed their larvae fresh insects (just the thorax is selected, the rest is chewed off), spiders or carrion. If a baby bird falls out of a nest, wasps or hornets use their jaws to cut out meat package takeaways for their brood back at the nest. On warm sunny days the nest is cooled as workers moisten the cells with water, which evaporates. Adult wasps and hornets visit flowers to feed on nectar; they also feed on ripe fruit – as this rots on the ground it ferments making the insects drunk and more aggressive. Another source of food is honey made by honeybees – if wasps can enter the nests to steal it.

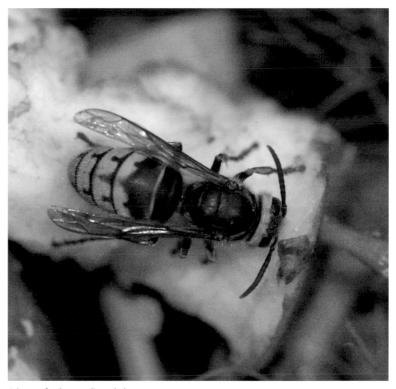

A hornet feeds on a discarded apple. 15 September 2008

The underside of a hornet shows brown and yellow colouration. 4 September 2008

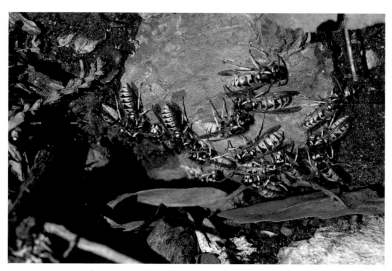

Common wasps sun themselves on *Taxodium* root
beside their nest entrance. 9 October 2008

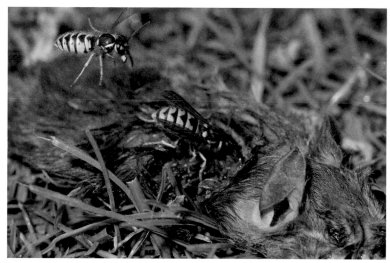

Common wasps cut out flesh packages from a dead
mouse to feed to their brood. 10 August 2007

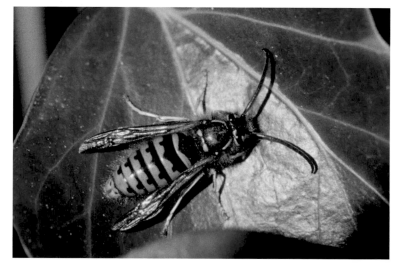

A common wasp sunbathes
on ivy. 18 October 2008

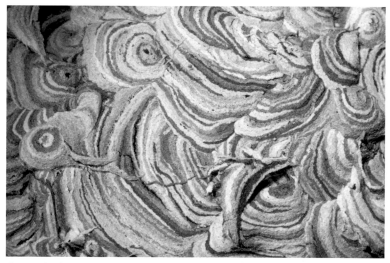

The outside of a common wasp's paper nest shows different coloured layers added by individual
wasps producing their own *papier maché* from wood scrapings and saliva. 15 June 2008

Berry bonanza

PHOTO TIP

Birds are creatures of habit; fallen berries give away where birds have been feeding and they will revisit the tree if it has not been stripped bare.

top
A ring-necked parakeet feeds on the red yew aril. 21 September 2008

middle
A blackbird feeds on an aril on a large yew tree at the south end of the Order Beds. 9 October 2008

bottom
A bumper crop of sea buckthorn fruits. 16 September 2007

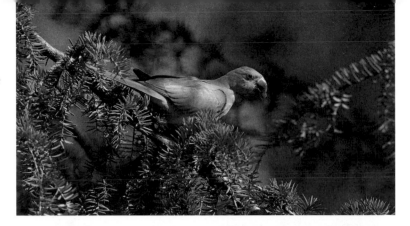

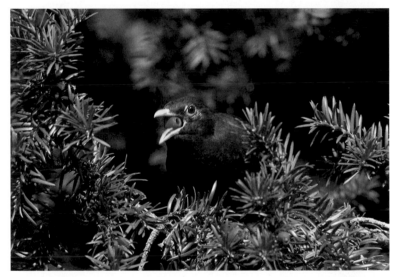

The colourful fruits borne by many trees and shrubs attract birds, as well as mammals, to feed and thereby help to disperse the seeds via their droppings. Fleshy fruits – often coloured red, orange or yellow – attract birds and small mammals which either gorge them *in situ* or carry them in their bill to feed in more secluded places. What happens to the seeds depends on their size; larger ones are discarded while smaller ones are swallowed and pass out through the bird via their droppings.

UK native hawthorn has smallish red fruits, but the diverse range of size and colour amongst hawthorn species can be seen at Kew in the hawthorn collection near the south end of the Temperate House. Here species with large red fruits and even some with black fruits can be found. These, together with the firethorns (*Pyracantha* spp.) and *Cotoneaster* also grown in this area, provide an autumnal feast for wood pigeons, blackbirds and thrushes as well as smaller birds and field mice.

The pink fruits of spindle (*Euonymus*) become even more attractive when they split open to reveal bright orange seeds inside. In some years sea buckthorn (*Hippophae rhamnoides*) produces copious orange fruits which are rich in vitamins C and E; they are made into a refreshing drink in China. This plant can be seen at Kew beside the Sir Joseph Banks Building Pond and near King William's Temple.

Evergreen holly (*Ilex aquifolium*) and yew (*Taxus baccata*) both produce male and female flowers on separate trees, with the fruit appearing only on female trees. In years when there is a copious supply of fruits, holly berries are left until after the soft fleshier berries of other trees have been devoured. Each yew seed nestles in a fleshy red cup, known as an aril. These arils attract a host of birds including blackbirds, starlings, thrushes and even ring-necked parakeets, which feed on the non-toxic sticky flesh. Some also swallow the hard seeds which are dispersed in bird droppings. All parts of the yew – apart from the arils – contain the highly poisonous alkaloid taxine. This will kill cattle or horses if they browse on yew. Deer, on the other hand, can eat yew branches because they are able to break down the alkaloid.

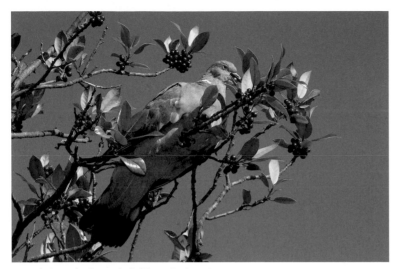

A wood pigeon feeds on a holly (*Ilex* x *altaclerensis* 'James G Esson') berry. 9 October 2008

Fallen *Crataegus baroussana* fruits amongst wood chippings. 28 September 2008

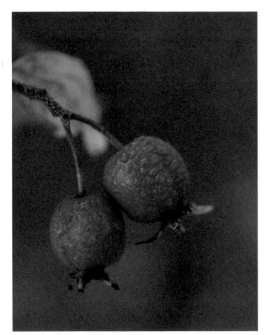

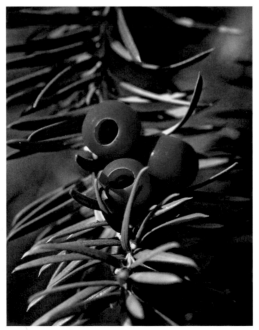

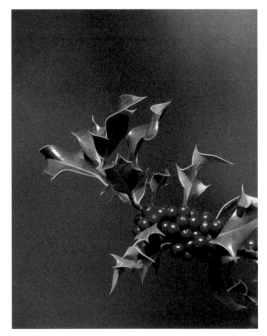

Crataegus baroussana fruits with dew. 28 September 2008

The red arils on yew which attract a host of birds have some unattractive local names including 'snotty gogs' and 'snottle berries'. 9 October 2008

Ripe holly berries don't last long at Kew before they are gorged by birds. 27 September 2008

Colour change

Sumach (*Rhus typhina*) leaves in autumn near the Sir Joseph Banks Building Pond.
18 October 2008

During the time deciduous trees bear green leaves, they create a sugar known as glucose from carbon dioxide and water, helped by the light-capturing pigment chlorophyll via photosynthesis. When autumn approaches, the hours of darkness lengthen as the days shorten. Glucose is no longer produced when water intake is reduced, as cold air carries much less water than warm air, and chlorophyll also begins to break down. Deciduous trees develop their ephemeral autumn tints prior to leaf fall, as a protection against water loss. Evergreen trees are able to retain their leaves as they have a thick waxy cuticle.

For the last three decades, colour change and leaf fall has begun one and a half days later per decade as climate change has resulted in an increase in carbon dioxide levels. Yellow, orange and brown pigments, known as carotenoids, previously masked by chlorophyll, are gradually revealed. The colour change is initially patchy, with the veins remaining green as the rest of the leaf begins to turn yellow or red. Intense yellow pigments develop in ash, some maple and hickory trees. Carotenoids also produce orange carrots, yellow buttercups and daffodils.

Red and purple colours develop on some deciduous trees in autumn; notably, red and scarlet oaks, sweetgums and dogwood. These arise from pigments known as anthocyanins, which develop in late summer as sugars break down in the presence of sunlight.

The best autumn colours occur when cold nights are interspersed with bright sunny days; whereas a prolonged spell of overcast damp days results in a poor autumn display. The effect of sunlight on colour change is easily apparent on an open standing tree where colour changes first on the side which receives most sun, whereas the north-facing side (in the northern hemisphere) will be the last to change. Also, leaves that overlap others will temporarily block the effect of the sun on those beneath. This is very obvious on a wall covered with Virginia creeper (*Parthenocissus* sp.).

Autumn colour is by no means confined to deciduous trees; some conifers also shed their leaves. Both swamp cypress and dawn redwood turn an attractive foxy brown, while the living fossil maidenhair tree turns a rich yellow.

Feathery dawn redwood leaves starting to turn a foxy brown colour. 15 October 2008

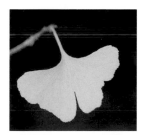

Golden fan-shaped leaves of the maidenhair tree turn a rich yellow in autumn. 28 October 2008

The five colours of beech leaves in autumn show sequential chlorophyll loss from green, green-yellow, yellow, yellow-gold to gold. 30 October 2008

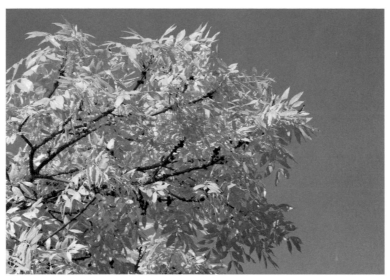

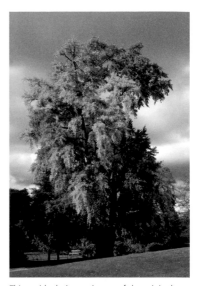

Red maple (*Acer rubrum*) leaves turn a vibrant red in autumn. 9 October 2008

Golden ash (*Fraxinus excelsior* 'Aurea') leaves turn a clear yellow. 27 September 2008

This maidenhair tree is one of the original trees at Kew, planted around 1762, and it turns yellow in stages. It is seen here against a stormy sky. 28 October 2008

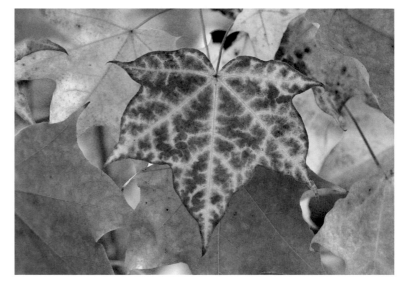

Sweet gum (*Liquidambar styraciflua*) leaves turn from yellow to red in autumn, showing how parts of leaves in direct sunlight change before parts hidden by other leaves. 28 October 2008

Cappadocian maple (*Acer cappadocicum* 'Aureum') leaf with yellow veins turned before the rest of the green leaf. 9 October 2008

Chestnut bounty

The parakeet's green plumage blends in so well with the green leaves it can be difficult to spot the bird. The best way is to scan back and forth across the tree looking for any localised movement.

top

A ring-necked parakeet uses its bill to prise away the chestnut husk.
27 September 2008

bottom

A parakeet holds a sweet chestnut in its foot to feed.
21 September 2008

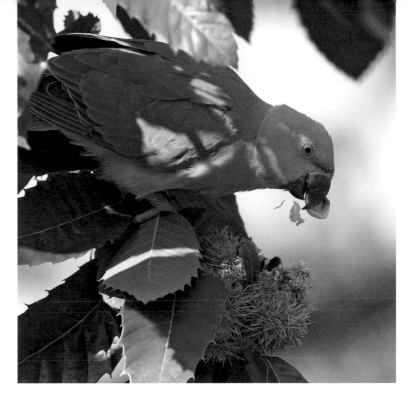

When sweet chestnut fruits are plentiful, they provide food for birds and mammals to feast on for several weeks. From mid-September grey squirrels can be seen rushing around beneath sweet chestnut trees checking fallen husks for the brown chestnuts. On finding one, the chestnut is extracted from the husk and held either in the paws for eating or in the mouth so the squirrel can dash off to bury its bounty. Claws on the front paws help to excavate a hole in the ground into which the chestnut is dropped before the ground is patted down with the paws.

If squirrels cannot find any chestnuts on the ground, they race up the trunk to the upper branches where the green fruits are bitten from their stalks so they plop onto the ground, or else the squirrels carry them down to the ground in their mouth.

But squirrels are not the only wildlife feasting on chestnuts. Fresh green leaves littering the ground beneath a sweet chestnut are a tell-tale sign that ring-necked parakeets have been at work, as they bite off leaves hiding chestnuts. These birds, which originate from India, are also known locally as posh pigeons and tend to feed in small flocks. They fly into the centre of the tree and make their way to an outer branch, hauling themselves along using their feet and multi-purpose beak. The powerful hook on this beak is used to pierce the green spiky husk and lever off portions until the chestnut can be plucked. The parakeet may clasp the chestnut in one foot, bringing it up to the hard beak so it can attack the tough outer casing. If a squirrel happens to approach too close to a feeding parakeet it is immediately seen off.

Jackdaws (*Corvus monedula*) have learnt to take advantage of chestnuts dropped by parakeets or squirrels feeding in the tree above. Early in the morning, clusters of jackdaws can be seen scouring the ground beneath recently worked trees. When a bird strikes lucky it is often mobbed by others, and so resorts to flying up into a tree where it can feed unmolested. This is an example of a native bird learning to benefit from the initiative of an alien species.

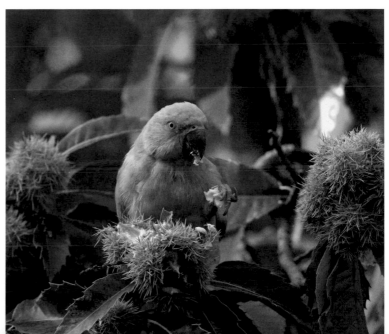

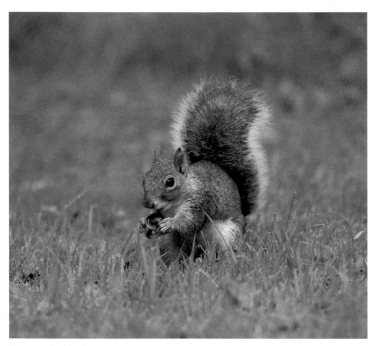

A grey squirrel feeds on a sweet chestnut. 21 September 2008

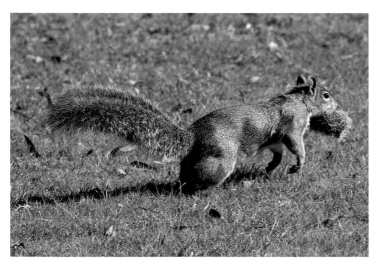

A grey squirrel runs with sweet chestnut fruits held in the mouth. 11 October 2008

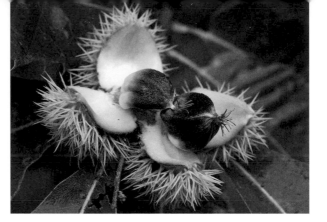

Ripe sweet chestnuts become exposed as the spiny husk splits open. 27 September 2008

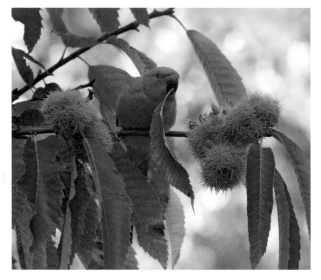

A ring-necked parakeet removes a sweet chestnut leaf prior to feeding on fruits. 11 October 2008

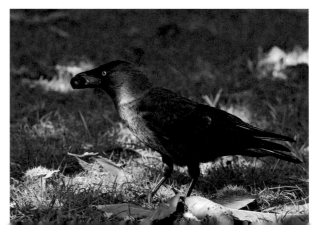

A chestnut dropped by a parakeet is swooped upon by a jackdaw. 27 September 2008

Feasting on acorns

PHOTO TIP

In a good mast year, birds and squirrels will work an oak tree with plenty of acorns for several days.

In years when weather conditions are favourable for wind-borne pollen to reach the female flowers on oak trees, a high volume of acorns are produced. Known as mast years, they provide plentiful food for a host of animals which forage on acorns in a variety of ways.

Even though a single species of oak will bear ripe acorns at the same time, birds tend to congregate on just one or a few trees, stripping them bare before moving on to other trees. When feeding on the outside of a tree, birds are clearly visible; but safety in numbers is a good strategy for alerting each other when danger threatens and a tree will then suddenly erupt as several dozen wood pigeons lift off from, for instance, a holm oak (*Quercus ilex*) in Syon Vista.

Jays (*Garrulus glandarius*) may alight on outer branches or fly to the top of a tree and move down to a fruiting branch; whereas wood pigeons are very noisy feeders constantly flapping their wings to prevent themselves falling from a branch as they bend down to feed.

Parakeets and squirrels are more agile and can hang from their feet and stretch down to reach acorns below. When birds are busily feeding, acorns rain down as some slip from the grasp of bills or feet. Jackdaws hang around beneath these trees where they can conserve energy by simply picking up fallen acorns. But they will also make Olympian leaps way off the ground in an attempt to pluck an acorn from a low branch. Acorns are also cached by jays and squirrels scatter-hoarding them in the turf, which aids seed dispersal of the heavy seeds away from the parent tree.

The acorn weevil (*Curculio glandium*) is a tiny insect that is totally dependent on acorns to complete its life history. The female has an elongated snout – the rostrum – which is used to drill a hole in the acorn so she can lay her eggs inside. After hatching, the larvae feed on the acorn kernel before drilling their exit holes.

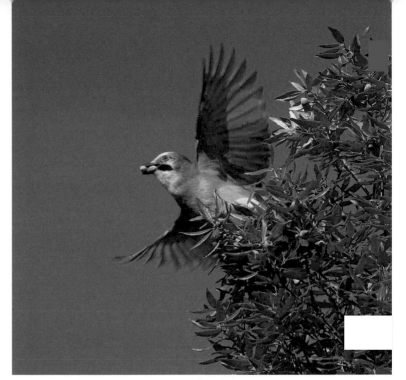

A jay feeds on a holm oak acorn. October 2008

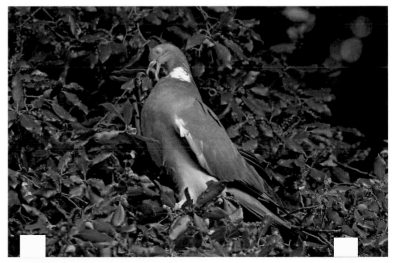

A wood pigeon stretches to feed on a holm oak acorn, with its eyelid fully closed. 9 October 2008

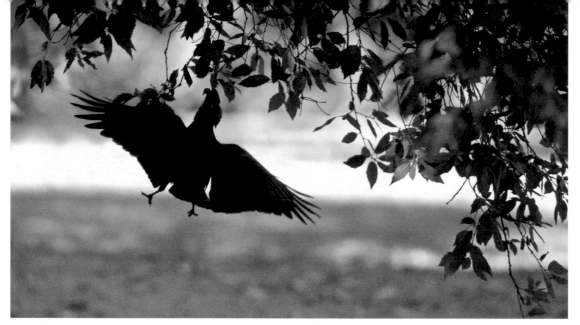

A jackdaw leaps to grasp a holm oak acorn from a low branch. 11 October 2008

Evergreen leaves of the holm oak with acorns that are smaller and more pointed than those of common oak. 11 October 2008

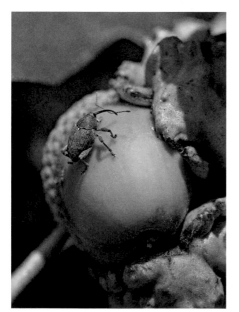

The diminutive acorn weevil has a long rostrum which is used to bore into an acorn before laying an egg. This acorn is infested with knopper galls. 11 August 2007

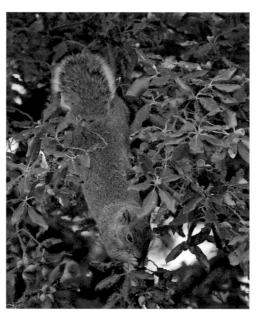

A grey squirrel feeds on holm oak acorn. 11 October 2008

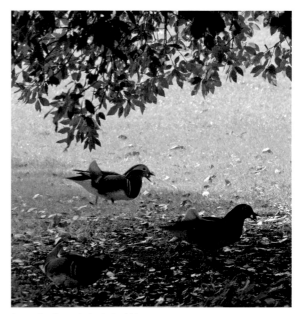

A gaggle of mandarin ducks (*Aix galericulata*) stop to forage on holm oak acorns. 27 September 2008

Mines and galls

The bramble leaf miner is one of many insect larvae that develop between the upper and lower surfaces of leaves by mining a tunnel inside the leaf. The female moth (*Stigmella aurella*) lays her eggs on the edge of the leaf where the larvae begin to eat out a tunnel along the periphery before turning towards the midrib.

Holly leaf mines, formed by a fly (*Phytomyza ilicis*), appear as yellow-purplish blotches. The pupa forms inside the mine and a neat exit hole confirms where the insect emerged; whereas v-shaped tears in the mine show the miner has been predated by a tit.

In 2002, the horse chestnut leaf miner was first recorded at Wimbledon in London. The first signs of this leaf miner (*Cameraria ohridella*) are white and brown blotches on the leaves from late April, and it causes the leaves to shrivel and drop off prematurely. Several generations of this moth develop during the summer; the last one over-winters as pupae within the mines, when they can be destroyed by burning the fallen leaves. Horse chestnut leaf miner has now become widespread over southern England and is spreading into Wales.

Galls are made by herbivorous insects causing their host plant to produce abnormal growths, which protect the insect and provide a food source. Galls can be found in every month of the year. The knopper gall wasp (*Andricus quercuscalicis)* has an elaborate life history. In summer, the female wasp lays her eggs in young acorns of common oak. Chemicals secreted by the larvae cause a green, sticky, ridged gall to develop on the acorn cup. Only female wasps emerge from the galls to lay their eggs in Turkey oak (*Quercus cerris*) buds. Both male and female wasps then emerge from the galls that appear on the male Turkey oak catkins the following spring.

The gall midge (*Taxomyia taxi*) makes a tufted artichoke gall on yew trees. A single egg laid on the yew bud causes the tip to swell and the terminal leaves to grow into a cluster to form the gall. After the larva changes into a pupa, the fly emerges in the summer.

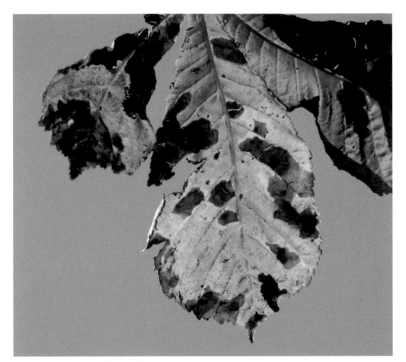

Horse chestnut leaves disfigured by the work of horse chestnut leaf miners. 11 September 2007

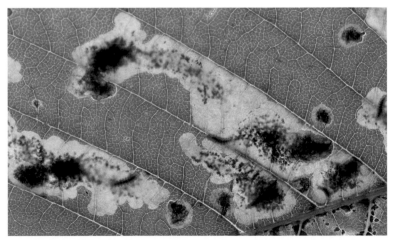

Larvae and frass trails of horse chestnut leaf miner larvae inside the leaves. 12 August 2007

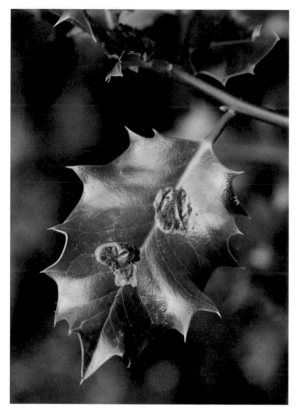

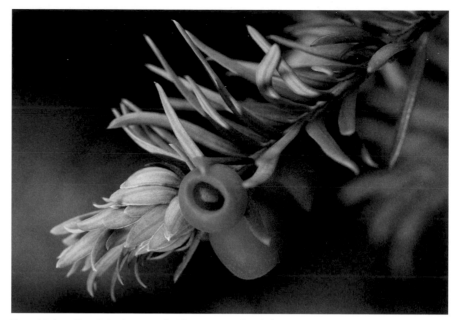

The artichoke gall made by the yew gall midge is green at first, before turning brown. Here it is seen with red arils. 1 November 2008

Blue tits (*Cyanistes caeruleus*) have opened both these holly leaf mines to eat the larvae inside. 18 October 2008

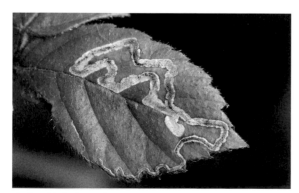

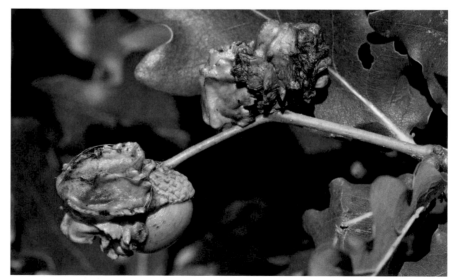

The bramble leaf mine first meanders along the leaf edge getting wider as the larva grows. 22 November 2008

Knopper galls on common oak acorns are produced by gall wasps. 11 August 2007

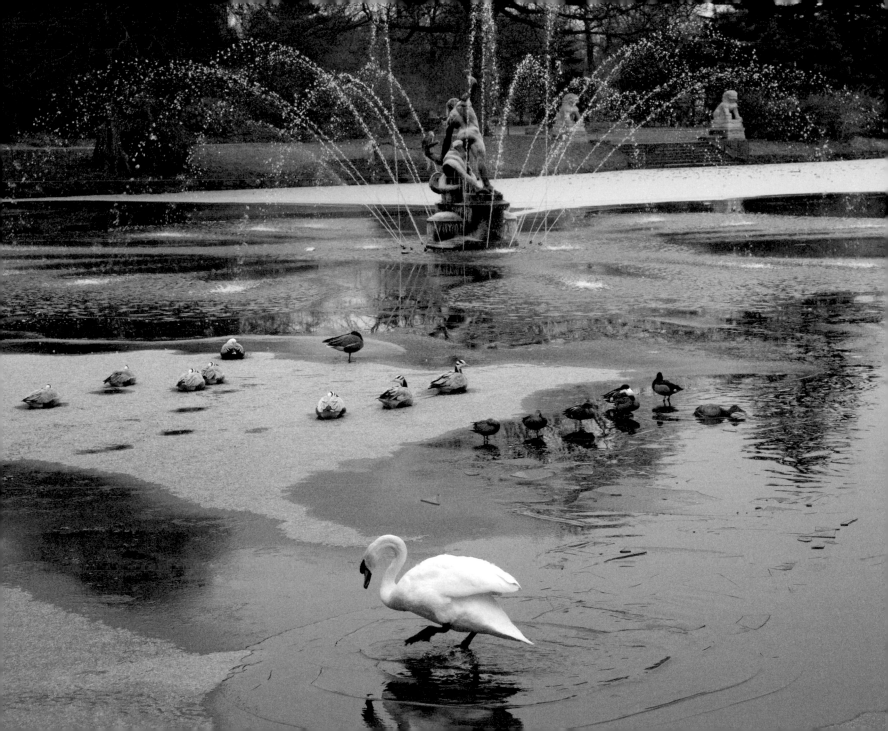

WINTER

With a short day length and cold temperatures, winter is not the most popular season to be outside; yet it brings unexpected wildlife sightings. It is one of the most rewarding seasons for looking at birds. Resident birds are joined by winter visitors. Diminuitive goldcrests (*Regulus regulus*) flit in amongst conifer branches. Coots merely swell the number of resident birds as do black-headed gulls (*Larus ridibundus*) which sport brown, not black, heads in winter. New arrivals include several different winter wildlfowl. Many gulls congregate on the Palm House Pond with some on the Lake too.

Winter flowers are especially welcome in a season when nature's colour has a limited palette. They include bulbs such as snowdrops (*Galanthus* spp.), the perennial Christmas rose (*Helleborus niger*) and a host of shrubs. A warm winter day may even bring out a hibernating butterfly, such as a peacock (*Inachis io*), homing in on winter box (*Sarcococca confusa*) flowers. With more light reaching a deciduous woodland floor in winter after leaf fall, mosses are able to grow in sunlit patches.

Prolonged cold spells during dry weather, as we had through much of December 2008 and January 2009, produces a ground frost but not a winter wonderland that encrusts shrubs and trees. Spectacular hoar frosts form well above ground, but only occur when freezing conditions coincide with a humid atmosphere such as mist or fog. If the wind blows from one direction, the ice then builds up on one side of the leaves and twigs in a spectacular formation.

left

In severe winters, the fountain keeps part of Palm House Pond ice free; the wildfowl on the ice include bar-headed geese and duck with a lone mute swan. 7 January 2009

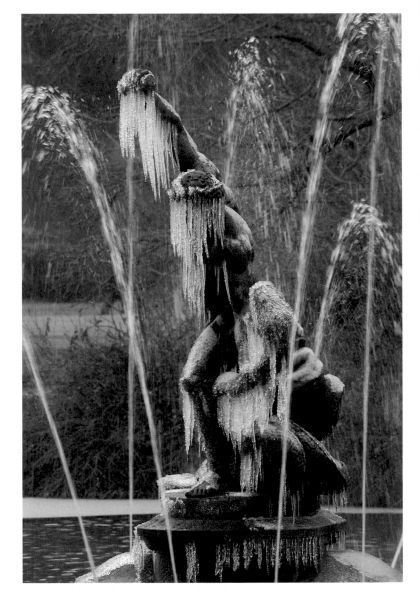

Dagger-like icicles add a new dimension to Hercules wrestling with the serpent river-god Achelous, in the Palm House Pond, with the ones on the face resembling dreadlocks. 10 January 2009

The 2008/2009 winter was the coldest for over a decade. On the Lake at Kew, all but one area – which the birds kept open by swimming and feeding – froze over. Open water was maintained in the Palm House Pond by the Hercules and Achelous fountain playing continuously. Climbing out on to ice that is just forming can be a laboured affair as the weight of a bird's body – especially a large bird such as a swan – breaks the ice. Even when a bird manages to stand on a thin ice platform just below the water, it may suddenly give way causing the bird to crash down into the water.

Early in February 2009, another meteorological record was broken with the heaviest recorded snowfall for 18 years. However, a thin snow cover is preferable for the clearest wildlife tracks and an early morning walk after a light overnight fall is sure to be rewarding. The nocturnal walkabouts of birds and mammals at Kew out of hours is then no longer a secret and you can appreciate just how widespread foxes are in the Gardens. Badgers (*Meles meles*) may emerge in winter but they are much less active than foxes at this time of year. Where tracks cross one another, they raise many questions. Which animal arrived first? Did they glimpse one another?

Winter is the season when many birds court and mate prior to nest building in early spring. Mute swans begin to lay the foundation of several nests after they start courting and mating, which can happen as early as January (page 116). However, they do not select the final nest site and begin to complete their huge metre-wide nest until well into the new year. Some ring-necked parakeets start breeding as early as January, meaning that they face little competition for the tree cavities in which they nest and so have a much wider choice of site.

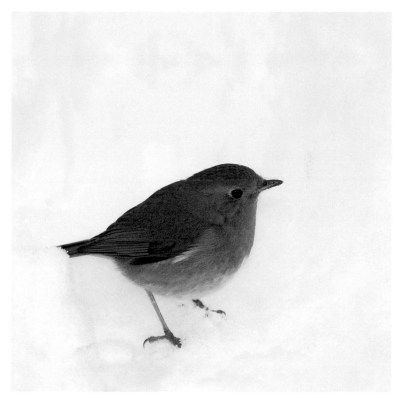

Robin (*Erithacus rubecula*) fluffed up on deep snow in the Conservation Area. 3 February 2009

right
Frozen Lake in winter, with red-stemmed dogwoods (*Cornus* sp.), leafless swamp cypress and *Metasequoia* still retaining autumnal leaves and an ivy clad tree behind. 9 January 2009

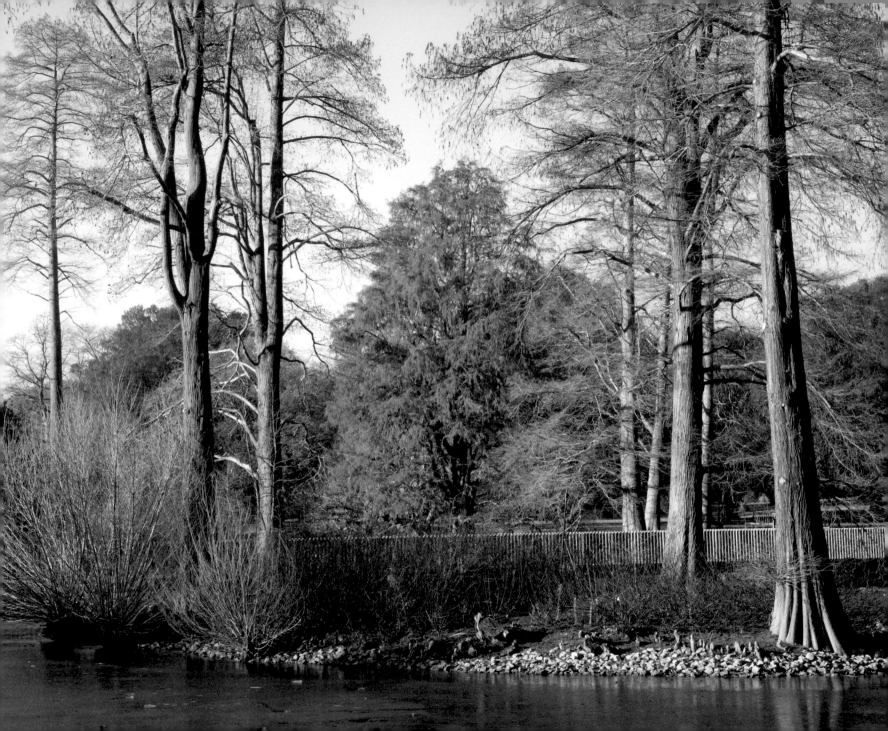

Essential water

top

A Canada goose bathes in the Palm House Pond on a cold winter morning. 3 February 2009

bottom

A mute swan flexes her wings after bathing. The mark on neck is where the cob held down her neck as they mated. 5 January 2009

PHOTO TIP

Water splashes created by a bird bathing show up best when they are backlit.

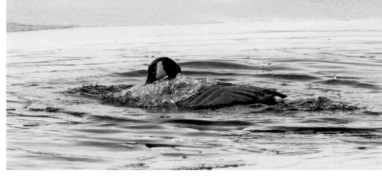

Birds and other wildlife need to take in liquids – whether from their food or by drinking water – to replace fluids which are lost by evaporation when they exhale or passed out in their droppings. They need a readily accessible supply of fresh water to drink throughout the year and most especially during severe winter periods when ponds freeze over. This is why the fountain continues to play during winter in the Palm House Pond.

The amount birds drink is highly variable; those that eat insects or earthworms require less water than seed eaters. It also depends on the weather. On hot days, the rate of water loss is much greater than on cool days. As birds graze on dew-covered grass early in the morning they gain some moisture, but more often they have to drink water from puddles, bird baths, ponds or melting ice. Birds drinking at the water's edge are most vulnerable to predation; this is why they periodically pause and look around.

Waterfowl and most garden birds have to bend down so the bill can be dipped into water before it is raised to allow the water to flow down the throat. The wood pigeon however, drinks by immersing its bill in water and sucking it up continuously like a straw.

So that feathers are kept clean and in good condition – especially to insulate birds in cold weather – birds also need to bathe regularly. This gets rid of dust and dirt and makes the feathers easier to preen. Healthy feathers ensure birds can take off speedily to escape from a predator. Waterfowl can be seen bathing by immersing their head in water and raising it up so the water drains down their backs. This is repeated several times before the wings are outstretched and flapped prior to preening taking place.

Squirrels and foxes drink from permanent water at Kew wherever bank sides are not too steep, such as the Rock Garden, the Waterlily Pond and some parts of the Lake.

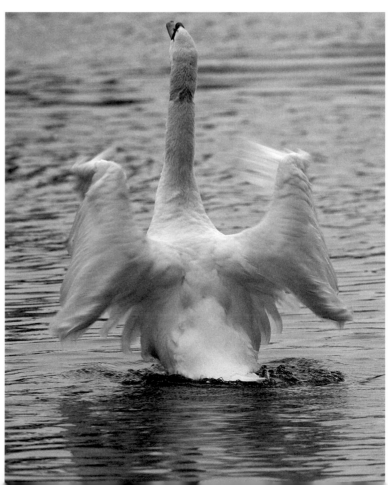

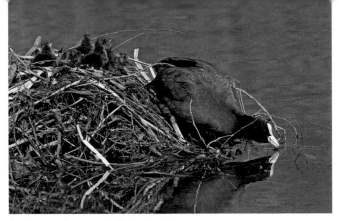

An adult coot leaves nest with six chicks to drink in the Lake. 10 April 2008

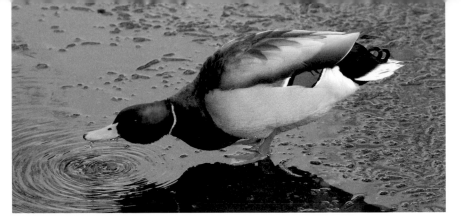

A mallard drake drinks from pool in melting ice on the frozen Lake. 5 January 2009

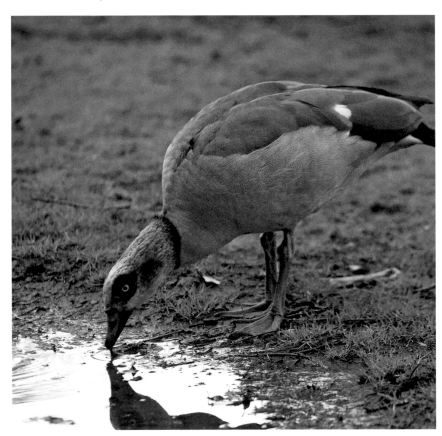

An Egyptian goose bends down to drink in a puddle after a rain shower. 17 April 2008

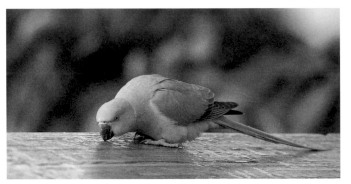

A ring-necked parakeet drinks dew from the Xstrata Treetop Walkway handrail, early in the morning. 18 October 2008

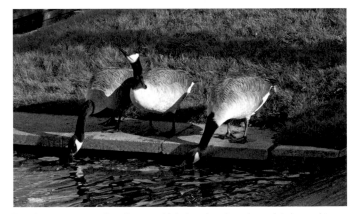

Two down, one up: as Canada geese drink they show how the neck is lowered to get water into the bill and raised so it can flow down the gullet. 28 October 2008

Scattering seeds

PHOTO TIP

Seeds bearing fine hairs need to be taken close up, preferably backlit.

top

Common lime fruits with their bracts, seen from the Xstrata Treetop Walkway. 8 June 2008

bottom

Each seed on a dandelion clock bears a hair-like parachute – or pappus – that carries it up into the air when the wind blows. 10 May 2008

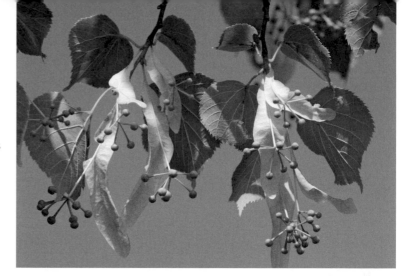

Examples of plants that rely on wind to disperse their seeds and fruits can be found in various seasons. All show special adaptations for being wafted away from the parent plant by the wind. One of the most familiar is the attractive dandelion (*Taraxacum officinale*) clock formed from a mass of miniature parachutes.

The greater reedmace or bulrush can produce up to 200,000 tiny fruits on a single flower spike which are wind dispersed by hairs. Amongst the fertile seeds are sterile flowers that absorb water and swell when it rains preventing the fruits from becoming sodden. During dry weather, the hairs spread open allowing the fruits to float away in the breeze. When they land on water, the hairs fold back so the fruit becomes wetted and the outer skin springs open to release the seed, which immediately sinks.

Older trees with large canopies cut out light on the ground below, so if their seeds are to germinate and flourish they need to be dispersed out in the open beyond their canopy footprint. Both trees and shrubs rely on wind and foraging animals to aid seed dispersal. One of the most graceful of all tree fruits has to be lime. Each fruit bears a conspicuous bract, which functions as a wing, spinning as it descends to the ground. Ash, sycamore (*Acer pseudoplatanus*) and field maple (*Acer campestre*) also produce winged seeds that helicopter down from the tree. Ash fruits, known as keys, hang from the branches in dense clusters and many remain on the bare branches through the winter. Pine (*Pinus sylvestris*) seeds, on the other hand, are hidden inside brown woody cones and are released only when the cone opens up in dry weather.

Unlike most of our native tree fruits, London plane bobbles are formed from a cluster of achenes (one-seeded fruit) that remain on the tree throughout the winter. The achenes are covered with stiff yellowish hairs which assist in seed dispersal as the bobbles break up during winter.

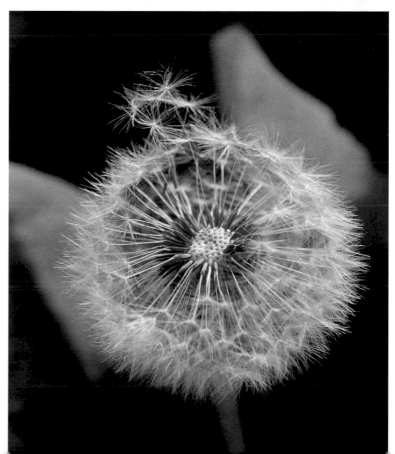

The tiny fruits of bulrush or greater reedmace are dispersed by wind. 31 January 2009

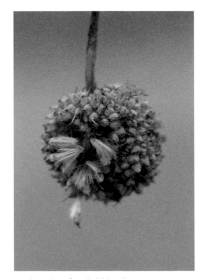

London plane fruit bobbles disintegrate in winter releasing individual fruits, each with four nut-like seeds and a tuft of yellowish hairs that aid dispersal by wind. 31 January 2009

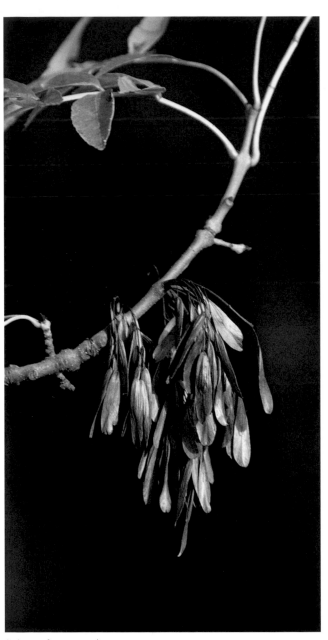

A cluster of common ash winged fruits are known as keys. 15 October 2008

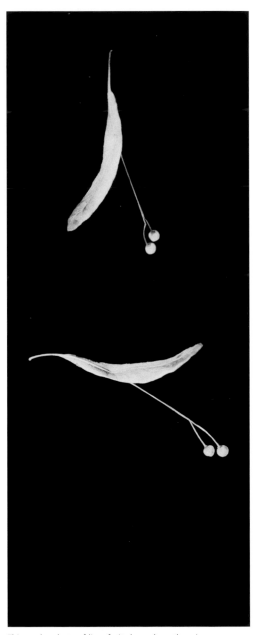

This strobe photo of lime fruit shows how the wing-like bract acts like a parachute to slow down its descent from the tree. 20 September 2008

Woodland birds

A blue tit perches on a snow covered log in winter.
3 February 2009

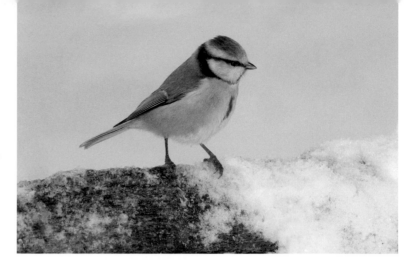

Winter is the best season to spot woodland birds because they are much easier to see amongst leafless deciduous trees. They are also more approachable at this time of year, because their urge to feed is much stronger than their apprehension of people at close range. Many a time in winter, when I put my photopack on the ground, a hopeful robin would fly down towards me. Blackbirds are also often seen when they turn over fallen leaves in search of invertebrate food.

The best place to see woodland birds at close range is in the Conservation Area beside the bird feeders, especially when the feeders have just been topped up. A host of tits, nuthatches and even ring-necked parakeets come to feed here, while jays either feed on food spilt from the feeders or else on grain placed on the fence posts. Walking along the paths in the Conservation Area you may find a tree creeper (*Certhia familiaris*) moving up and down a trunk extracting insects, but a top attraction is the glorious golden pheasants parading through the bluebells (page 22) in spring.

The latest annual Woodland Bird Survey in Britain shows that goldcrests, tits, the green woodpecker (*Picus viridis*) and the great spotted woodpecker (*Dendrocopos major*) are all on the increase. Viewing woodpeckers on tree trunks is invariably frustrating since as soon as they spot you they move out of site behind the trunk. A good place to watch the green woodpecker is on lawns where they feed on ants early or late in the day.

Noisy flocks of ring-necked parakeets are heard before they are seen flying over the trees tops at Kew. Other birds give way to them when they move onto the feeders and when fruits are ripe many gather to gorge themselves on the same tree. These parakeets are now a common site in west London – notably along the Thames from Kew to Hampton Court. One pair can successfully rear 3–4 offspring, which soon swells the population. There is no firm evidence that they are competing with our native birds, but the fact that they nest early must mean that other hole-nesting birds will have to work harder to find a nest site.

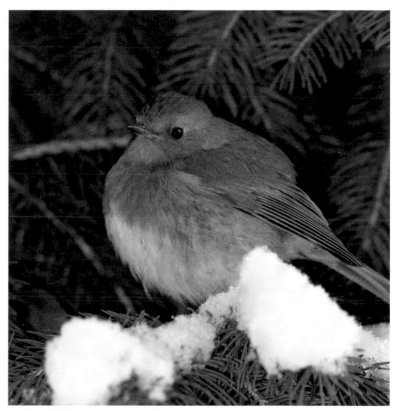

A robin puffed up on a snow-covered conifer branch. 3 February 2009

Ring-necked parakeets courting in the
Conservation Area. 22 November 2008

A jay perches on a fence near bird
feeders. 29 December 2008

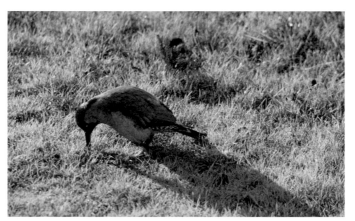

A green woodpecker feeds on ants in a lawn
in the early morning. 11 October 2008

Natural designs

PHOTO TIP

Pause to focus more carefully on parts of plants – especially leaves, which can provide wonderful abstracts or powerful designs for macro subjects.

Patterns and designs abound amongst the plants grown at Kew. After flowers have faded outside, leaf shapes are appreciated all the more. Fallen pine cones and thick evergreen monkey puzzle (*Araucaria araucana*) leaves have a spiral design. Many succulent plants have leaves arranged in a spiral pattern and substantial yellow spines grow in spiral lines on the large golden barrel cacti (*Echinocactus grusonii*). On wet winter days warm, dry glasshouses have much greater appeal than the outside.

Spirals can also be seen in many climbing plants, either at the apex of the stem, ends of leaves or as modified leaves for anchoring themselves onto other plants as they grow upwards. New shoots of ferns are typically contained within a spiral, known as a crosier, which is often covered with brown scales. The flowers (and later the seeds) within the centre of single sunflowers (*Helianthus annuus*) are arranged in an exquisite pattern of several spirals.

In the wet tropics section of the Princess of Wales Conservatory there are plants with attractive leaves caused by distinctive venation patterns or random variation – indeed several begonias with striking leaves are popular house plants. The bright colour of bromeliads never fail to impress whether they are radially symmetrical forms with colourful bracts surrounding massed tiny flowers or upright flower spikes with flowers emerging from an erect spike of coloured bracts. Passionflowers (*Passiflora* spp.) and cacti both produce radially symmetrical flowers.

A rich Italian merchant, known as Leonardo Fibonacci, who lived in Pisa in the thirteenth century, became fascinated by mathematical observations. It was he who discovered a sequence of numbers – now known as the Fibonacci Sequence – which frequently occur in nature. Taking the sequence 0 1 1 2 3 5 8 13 21 34 55, each successive number (after the first two) is the sum of the previous two numbers. Trilliums have three petals and three sepals, whilst five petals are not uncommon amongst our wildflowers (buttercup, wild rose and pinks) whereas ragwort and corn marigold both have 13 petals.

The stunning fruit of *Heliconia collinsiana* var. *collinsiana*. 31 January 2009

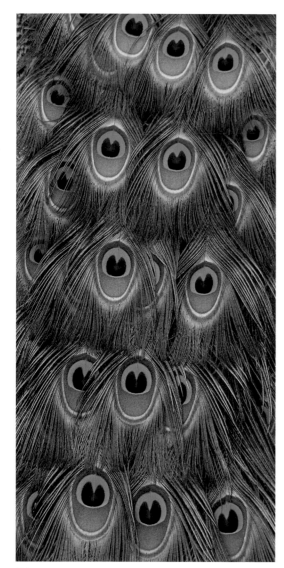

Iridescent eye spots on
blue peacock train feathers.
24 January 2009

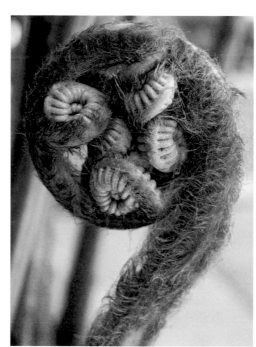

Crosier of hapu-upulu (*Cibotium glaucum*)
from Hawaii, USA. 20 June 2007

The evergreen leaves of the
monkey puzzle tree are arranged
in a spiral. 18 October 2008

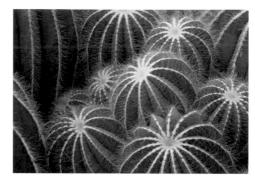

Parodia magnifica cactus spines emerge
from ridges. 24 January 2009

Abstract of a prayer plant leaf – one of the calatheas
originating from tropical America that is cultivated as a
popular pot plant. 31 January 2009

Grazers

Approximately three-fifths of Kew's 132 hectares are lawn, which provides plenty of scope for animals to graze all year round. Wildfowl with a young family tend to graze fairly close to water, so they can make a speedy escape if necessary. Soon after first light various geese – Canada, bar-headed and Egyptian – can be seen grazing in pairs or families around the Lake. Canada geese also feed on the lawn beside the Sir Joseph Banks Building Pond. At this time of day they may have the added advantage of gaining moisture from dew if present. Later in the morning they tend to move further away from the water and some geese follow the same route each day.

When several Canada geese families join up to form a large gaggle, they are very conspicuous, parading down Syon Vista periodically stopping to feed. Moorhens, coots and swans vary their diet by feeding on freshwater algae and anything else they find in water and emerging on land to feed on grass. Here, they also spend time preening before making the next foray onto water. Even when a severe ground frost covers the lawns, various geese can be seen grazing early in the day long before the frost has melted. They start feeding standing up but invariably end up sitting down – no doubt because their feathered bodies are better insulated than the bare skin on their webbed feet.

These are the obvious grazers to be seen at Kew but there are also much smaller fry which depend on grass. In spring and summer the caterpillars of speckled wood, meadow brown, gatekeeper, and small and large skipper butterflies all feast on native grasses which have not been mown. This is why patches of long grass with wild flowers are present in many parts of Kew.

Then there is the night shift which emerges to graze after Kew is closed. A torch panned across any lawn on a wet night will reveal an armada of slugs and snails, with the odd one lingering after dawn on wet mornings.

Late in the year, many more coots join the resident coots as winter visitors. Large groups appear on the Lake and when this becomes frozen, they emerge to graze on the lawns.

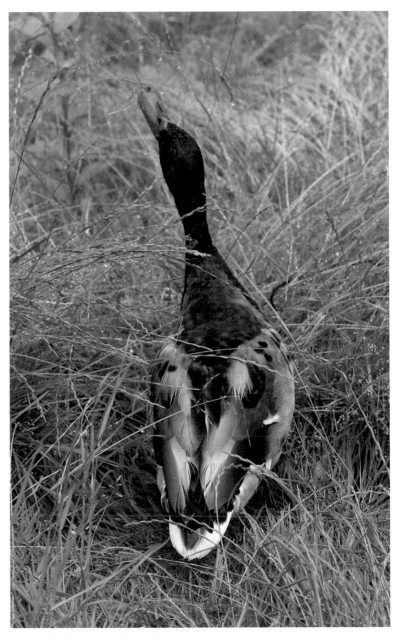

A mallard feeds on grass seeds beside the Palm House Pond. 21 June 2008

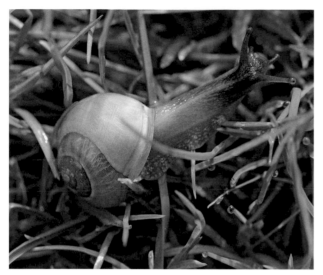

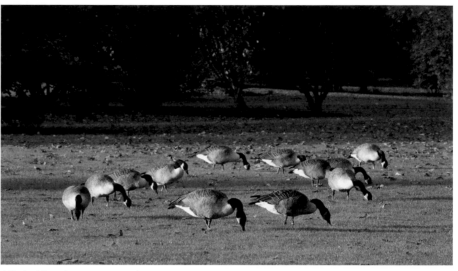

At first light a white-lipped snail (*Cepaea hortensis*) crawls on a lawn with water drops excreted overnight from grass tips by guttation. This is distinct from dew, which condenses from the atmosphere onto the whole plant. 1 May 2008

A flock of Canada geese graze on lawn at dawn. 18 October 2008

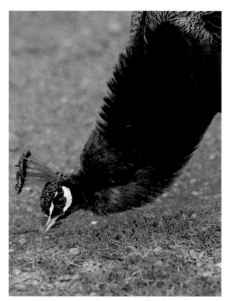

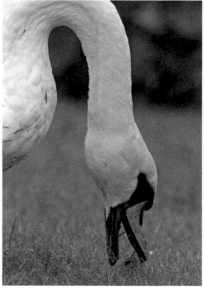

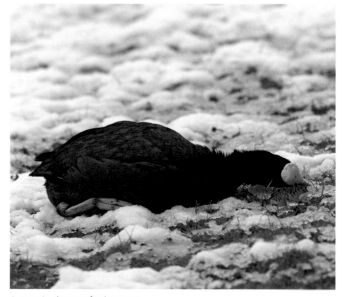

After displaying to a peahen, a peacock plucks at grass. 24 January 2009

A mute swan grazes on grass with dew early in morning. 27 September 2008

A coot sits down to feed on grass beneath a late snow fall. 6 April 2008

Winter blooms

PHOTO TIP

Snow and thick frosts rarely last long at Kew, so it pays to get there early before the white mantle shrinks from the warmth of the sun's rays.

top
Frost-covered witch hazel (*Hamamelis mollis*) flowers. 10 January 2009

bottom
Waxy flowers of wintersweet are produced on bare woody branches and emit a sweet scent at Christmas time. 9 January 2009

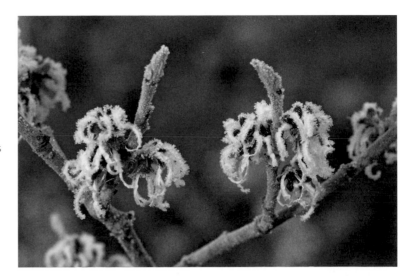

Wild snowdrops (*Galanthus nivalis*) may be synonymous with winter but the true Christmas bloom is the Christmas rose, also known as the winter rose, which bears white flowers tipped with pink within the mountains of central Europe. Several shrubs, also not native to Britain, enliven the dullest of winter garden days. Wintersweet (*Chimonanthus praecox*) produces fragrant flowers on bare branches. This shrub grows in montane forests in central and south China, where it has long been cultivated as a decorative plant for its fragrant flowers. The leaves, roots, flowers and seeds are also used medicinally.

Another shrub which produces flowers on leafless branches is witch hazel (*Hamamelis* spp.), with curious narrow petals looking as though they have been shredded. The flowers are most often yellow but are available in autumnal colours ranging from bronze, through to copper and to red. This plant is well known for its healing powers and the spiderery flowers provides a warm, spicy scent in January.

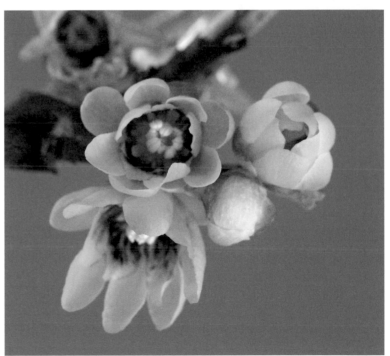

Viburnums with large showy flowerheads appear with leaves in summer; those that flower in winter have small compact heads on bare stems. *Viburnum* x *bodnantense* has sweetly scented white flowers with a hint of pink well before Christmas into January. This, together with wintersweet and other winter-flowering shrubs, can be seen near the Ice House at Kew. *Mahonia* flowers appear in long yellow racemes above evergreen, prickly, pinnate leaves. On warm winter days, bees emerge to forage on the flowers to top up their food supplies.

Snowdrops, once known as Candlemas bells, have been cultivated as far back as Medieval times. Carpets burst into flower beside the path in the wooded part of the Conservation Area. My aim was to photograph them with a light sprinkling of snow but when the snow fell in early February it was so deep it completely covered them! The drug galantamine, derived from snowdrops and daffodils, is used to slow the process of the early stages of Alzheimers disease. Daffodils – the Welsh national flower – are now being grown by Welsh hill farmers for harvesting galantamine.

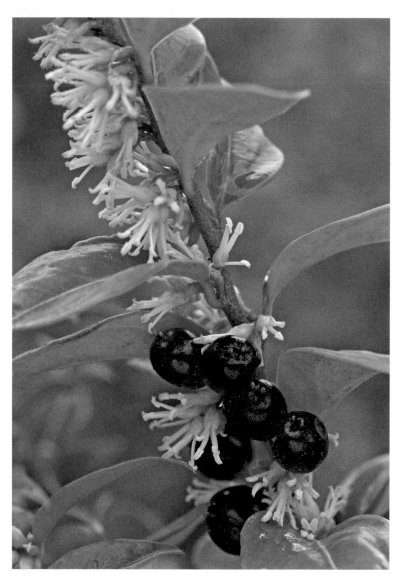

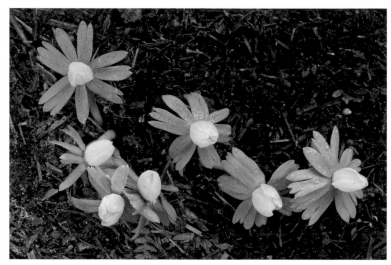

Winter aconite (*Eranthis hyemalis* 'Aurantiaca')
flowers survive being frosted. 24 January 2009

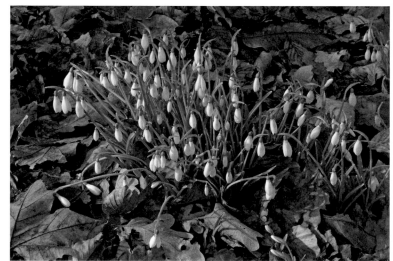

Winter box has small, white, scented
flowers and black fruits. 24 January 2009

Snowdrops emerge through leaf litter near the
Xstrata Treetop Walkway. 24 January 2009

Boxing Day

PHOTO TIP

Time spent watching the way wildfowl feed or interact with one another is well spent, because it is then possible to predict when the action is likely to occur ensuring you release the shutter at the optimum moment.

Having spent the longest day (21 June) at Kew, the plan was to spend the shortest day (21 December) there too. But the dismal cloudy forecast persuaded me to postpone the visit until the first sunny day – dull winter days look so drab and unphotogenic. As it happened, Boxing Day had much better light than in June, although there was less than half the number of daylight hours (7 hours 51 minutes compared with 16 hours 38 minutes). So the time available for diurnal (active by day) animals to feed is greatly reduced, however at this time of year they do not have a young family to feed.

It was one of those glorious winter days – bitterly cold but sunny. A peacock was out shortly after first light feeding on a sunny patch of lawn, but when a gust of cold wind blew, it immediately took off and alighted in a sunspot to warm up. Guinea fowl (*Numida meleagris*) were intermittently feeding and preening; moving as they fed, they rapidly did an about turn when they moved into a shady patch. Fully extended catkins of some European species of alders were blowing in the breeze and shedding their windborne pollen grains, but snowdrops had yet to open in the Conservation Area.

The Lake was bursting with activity – some coots were fighting by running towards each other and then leaning backwards in the water so they could use their wings and lobed feet to kick up spray into the face of their opponent. All this created a spectacular and dramatic episode, but no harm was done as one coot soon gave way and retreated.

In the Conservation Area, bird feeders well stocked by visitors provided enough food to ensure constant toing and froing by tits, robins and nuthatches with the occasional squirrel; while food spilt on the ground lured in wood pigeons, jays and even a young fox that regularly visited in the mornings. Later in the day, parakeets landed in trees nearby and began to feed on alder catkins, biting them off near their base. When several parakeets arrived at the feeders the smaller birds immediately gave way to them.

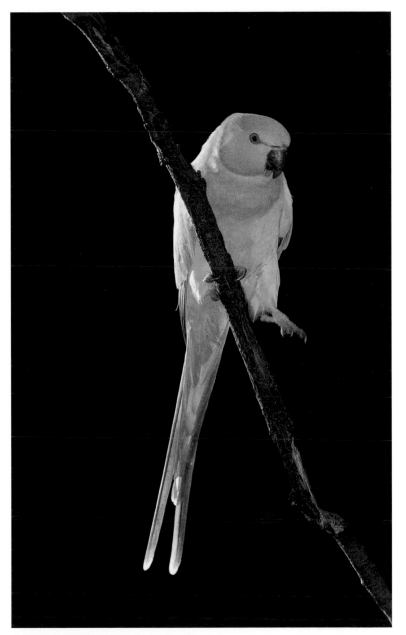

A ring-necked parakeet moves down a branch towards a bird feeder. 26 December 2008

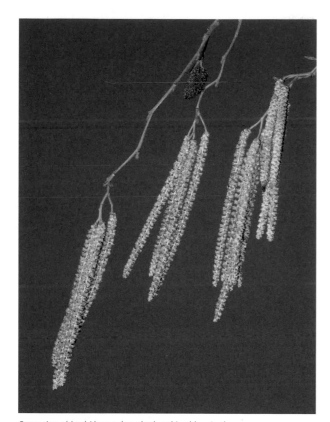

Caucasian alder (*Alnus subcordata*) catkins blow in the wind against a clear blue sky. 26 December 2008

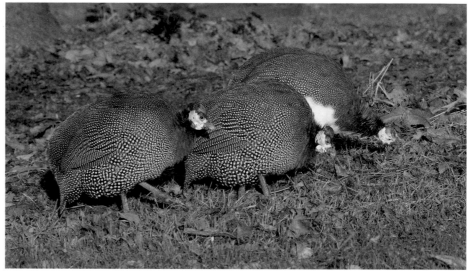

Domesticated guinea fowl feed in the winter sun. 26 December 2008

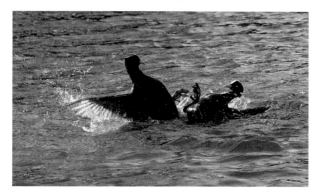

When coots fight on the Lake they send up a spectacular water display. 26 December 2008

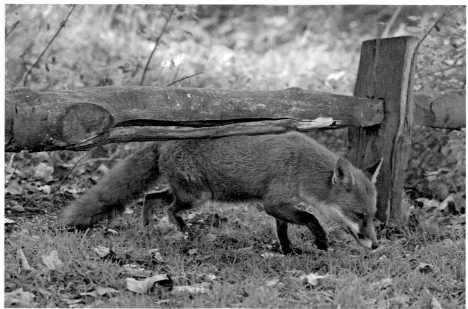

A fox emerges from a wooded part of the Conservation Area, by squeezing beneath the wooden rail fence. 26 December 2008

Bark textures

top

The flaking bark of a London plane tree.
24 January 2009

bottom

Deeply-ridged sweet chestnut bark develops a spiral growth in old trees.
26 December 2008

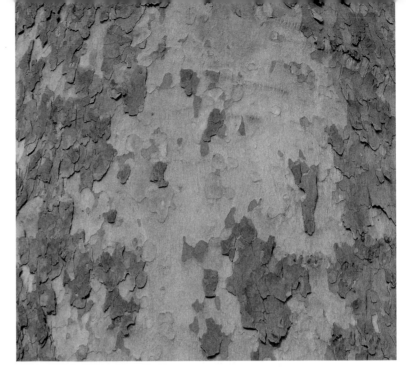

Winter is an excellent time to appreciate the colours and textures of bark. Boles of deciduous trees are more evenly lit after leaf fall, and the low-angled winter sun illuminates trunks better than a high summer sun. There are many examples of trees which slough their bark at Kew – notably the London plane which was able to flourish in the notorious London smogs by constantly shedding the polluted outer layer. The bark falls only from mature London plane trees in large flakes to reveal white-yellow patches beneath.

Stewartia pseudocamellia from Japan is a small tree that bears solitary white flowers in summer and has a striking bark which is a mix of the pale under layer decorated with remnants of the outer brown layer. Many maples are grown primarily for their autumnal colours, whereas the main appeal of the Chinese paperbark maple (*Acer griseum*) is its attractive cinnamon-coloured flaking bark. As large portions peel away and are backlit by the sun, they visibly glow.

The lacebark or Bunge's pine (*Pinus bungeana*) is a coniferous tree that sheds its bark and deserves to be better known. Originating from north-west China, it is named after a Dr Bunge who discovered it in a temple garden near Beijing in 1831. The bark flakes away to reveal white patches which change colour with age from yellow to pale green, olive, rufous and pink. The end result is a mosaic of colours that blend one with the other.

Notable birches that shed their bark to reveal striking horizontal markings are the paper or canoe birch (*Betula papyrifera*) from North America, *B. albosinensis* from China and *B. ermanii* from north-east Asia. Snakebark maples from China and Japan have striking two-toned textured barks with vertical markings.

Sweet chestnut trees have deep furrows that run up and down their trunks. As the tree ages, the ridges twist around the trunk, making them even more attractive. Near the east end of the Lake there are several grand old sweet chestnuts with spiralling bark. These furrows provide hideaways for over-wintering insects.

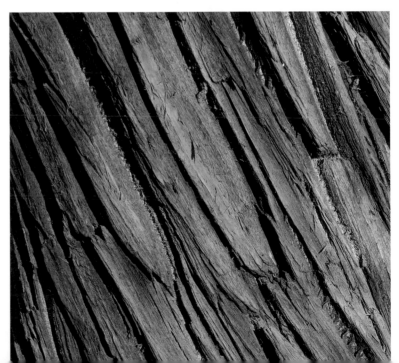

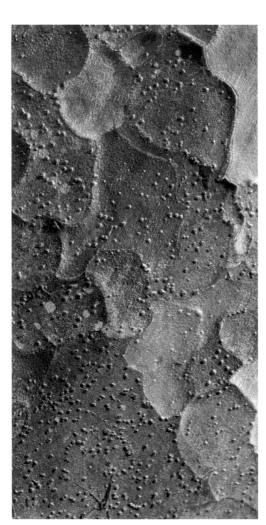

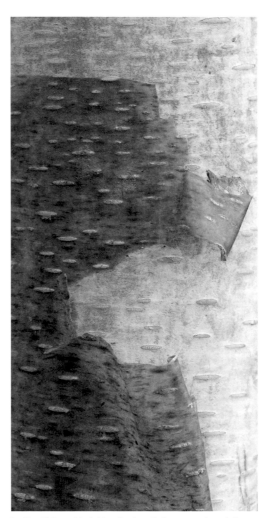

Cinnamon coloured flaking bark
of a Chinese paperbark maple.
24 January 2009

The colourful mosaic of lacebark
pine bark is enhanced after rain.
29 December 2008

Peeling Sichuan birch (*Betula platyphylla* var. *szechuanica*)
bark has distinct transverse lenticels, which allow exchange
of gasses between the air and the tree's internal tissues.
31 January 2009

Amorous swans

Of all our native birds, the mute swan has the most enchanting courtship behaviour sequences to witness. Once two swans pair, they remain mates for life; although when one swan dies the survivor will seek another mate. Their courtship and mating take place in winter and because these large birds make their display out on open water, over a period of several weeks, they are easily seen. Before they mate, the birds raise and lower their bills by dipping them in and out of the water, preen or rub bills against their flanks as they swim in slow circles. Initially these movements alternate from one swan to the other until they begin to bill dip in unison – reminiscent of synchronised swimmers.

When the pen (female) lies prone in the water, the cob (male) hops on top of her and mates, grasping her neck giving the impressioon he is about to drown her. Immediately after mating, the male dismounts and both swans rise up out of the water. Frantically back paddling – they appear to be walking on water – they face each other with their breasts touching and their necks extended and partially entwined. Their bills move in sequence, initially skywards, then down and finally from side to side in delightful balletic movements. As their breasts and bills touch, the area between them forms a more upright heart-shaped space than when the birds court whilst sitting in the water. After this display, the pair separate and go their own ways to wash and preen.

It is only a matter of minutes from when the cob mounts the pen through to the post-courtship display, but an actively courting pair will repeat their amorous display through winter and even into spring. I was lucky enough to see the pair on the Palm House Pond display twice in one week in early January.

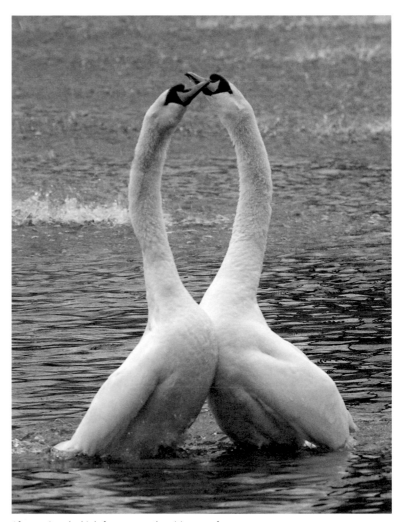

After mating, the birds face one another rising out of the water with extended necks. 5 January 2009

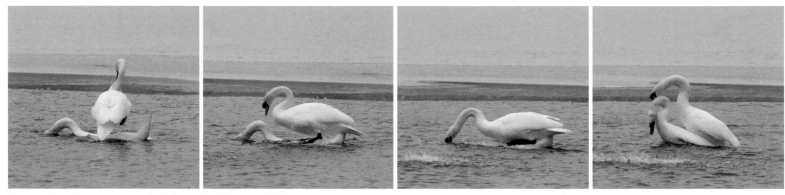

Sequence of mating mute swans on Palm House Pond. 7 January 2009

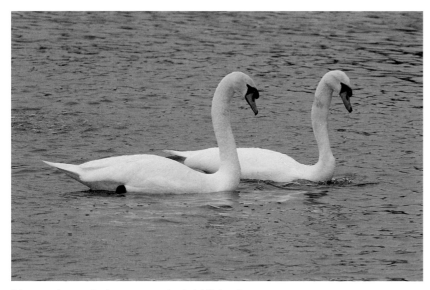

Prior to mating, a pair of mute swans raise their bills in unison after bill dipping in the Palm House Pond. 7 January 2009

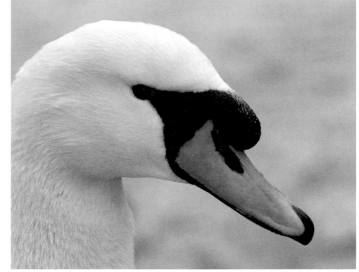

The cob has a distinct black swelling above his bill. 10 January 2009

117

Living lichens

PHOTO TIP

Unlike leaves and flowers, encrusting lichens on a wall or a solid tree trunk do not move on a windy day. If the light is poor, use a notebook covered with cooking foil as a mini reflector to boost it.

When looking at bark in winter, various coloured – yellow, grey or pale green – encrusting growths may be seen on the main trunk or on the branches of some trees. These are lichens, a curious intimate association formed from two quite different organisms. The major one, which gives the lichen its shape and structure, is a fungus that surrounds typically green algal or cyanobacteria cells, both of which contain green chlorophyll. This allows them to produce carbohydrate food via photosynthesis in the presence of sunlight, in the same way as green plants.

The fungus provides its partner with minerals and water as well as protection from harmful ultraviolet light; in exchange for food which it cannot produce itself. Such an association of apparently equal benefit is known as mutualism, but some biologists now think the fungus may benefit more than the other partner.

Lichens can survive a wide range of climatic conditions from Antarctica to deserts. They will also tolerate a prolonged dry spell better than more delicate flowering plants. Lichens have no roots and can colonise some microhabitats without having to compete with other organisms; for example the surfaces of bare rock and walls. Lichens that grow on trees are known as epiphytes, as they grow attached to the bark without causing damage to the tree.

At Kew lichens can be found growing on the wall of the Palm House Pond, on weathered rocks in the Rock Garden, as well as on older wooden seats where birds perch on the backs. Bark which is rough is more likely to bear lichens than smooth bark. Extensive orange lichen growths will be found on or below branches where birds repeatedly perch; their droppings provide minerals that aid lichen growth.

Lichens absorb water and minerals from rainwater and the air and are very sensitive to atmospheric pollution, so they can be used as indicators of air pollution levels.

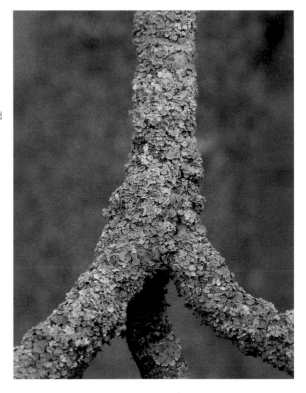

This yellow crustose lichen *Xanthoria parietina* adds colour and texture to a narrow leaved ash (*Fraxinus angustifolia*) winter twig. 6 April 2008

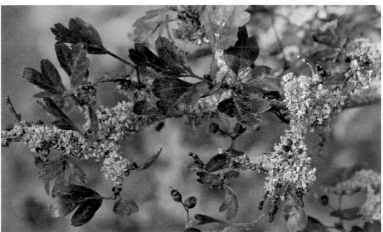

Red leaves of a hawthorn (*Crataegus monogyna* 'Semperflorens'), with grey crustose lichens (*Physcia* spp.). 28 September 2008

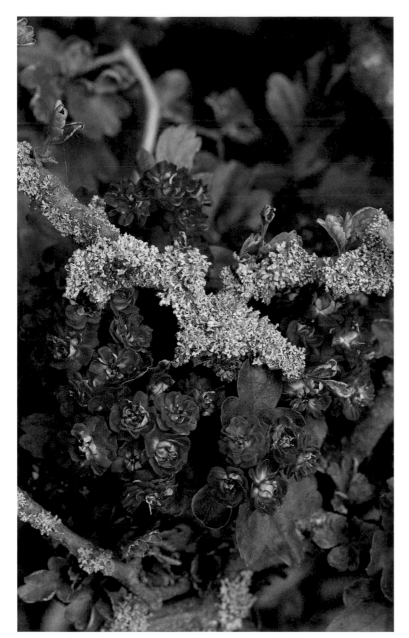

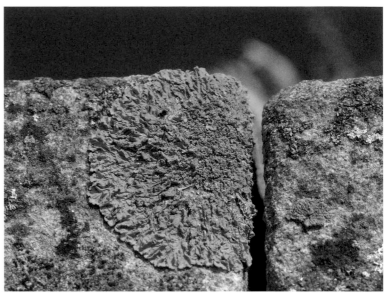

Encrusting lichen, *Xanthoria parietina* on wall beside the Palm House Pond. 11 August 2007

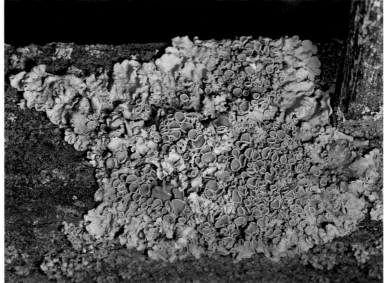

Double pink flowers of an ornamental hawthorn 'Pink corkscrew' add colour contrast to the grey lichen- (*Physcia adscendens*) encrusted branches. 14 May 2008

Encrusting lichen, *Xanthoria parietina* with fruiting bodies that resemble miniature tarts, on the back of a weathered wooden seat. 7 January 2009

Ice and snow

PHOTO TIP

If snow is forecast, get out early in the day to look for tracks before the snow melts.

top

Etched in snow, the leafless winter skeleton of a common oak tree appears statuesque. 3 February 2009

bottom

Crossroads: waterfowl and fox tracks intersect on the snow-covered frozen Lake. 5 January 2009

Snow rarely falls in southern England, so a pristine blanket of snow never fails to delight. It acts like a huge reflector throwing light up infilling shadows on the underside of branches. If a recent fall happens to coincide with a blue sky, the contrast is quite breathtaking. Freezing temperatures transform areas of open water at Kew – especially the Lake and the Palm House Pond. Parts of the Lake are kept ice free by the constant movement of birds swimming and upending. Here, dabchicks can continue diving for small fish, but the restricted area means most of the coots move out onto land to feed on the lawns.

If all easily accessible water supplies are frozen on land, wildfowl – as well as terrestrial birds – will fly or walk onto an icy pond or lake to gain access to open water to drink. At the ice/water interface the ice can be very thin if it melts by day and freezes over at night, and so is easily broken. A sudden audible crack often startles the birds – especially the first time they experience it – they either stop dead in their tracks or else leap up off the ice. When the ice begins to melt and the surface becomes soft and slippery, the birds sometimes slide forward or land ignominiously on their behinds when they come in to land.

When wildfowl swim their feet are immersed in the water and even when walking on grass they are partially hidden. Therefore, it is revealing to see clearly the large lobed feet of coots and mallards' bright orange legs and feet as they walk over ice. If a coot fight develops on ice, the way their feet are used becomes much clearer to see than amongst a flurry of water splashes (page 113). Where the birds have walked over the slushy ice, small pools of water appear that become invaluable miniature drinking pools.

After a light snowfall covers paths and wildlife walk over it – by day or night – their tracks and footprints are revealed as dark impressions within the white snow. However, unless the daytime temperatures remain below freezing, they melt into oblivion by mid-morning.

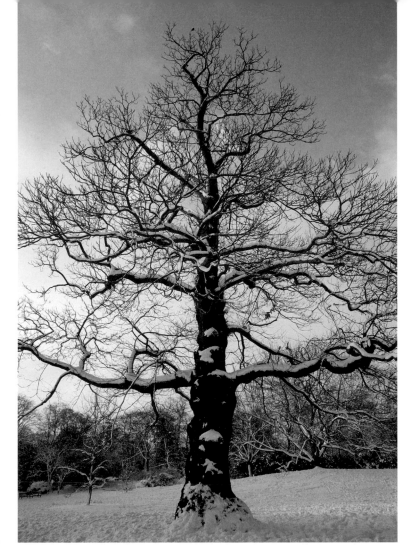

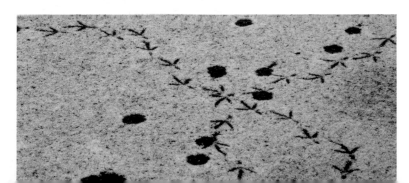

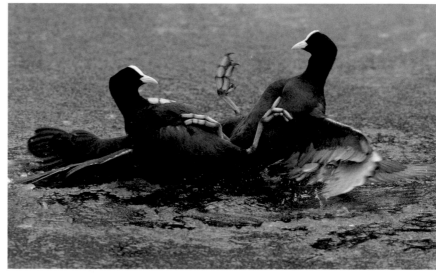

A *ménage à trois* – two mallard drakes followed everywhere by a duck on the iced-up Lake. 5 January 2009

Two coots spar on a frozen lake with their outstretched wings laid back as they fight each other with their clawed lobed feet. 5 January 2009

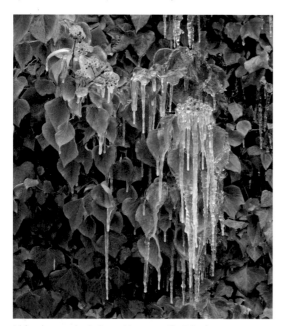

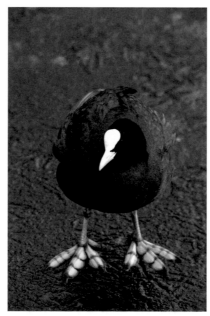

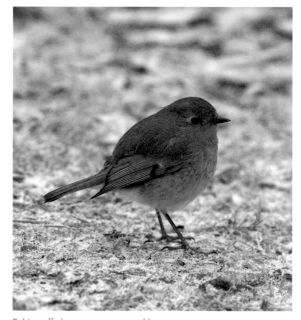

Icicles decorate ivy fruits and leaves on the School of Horticulture building. 10 January 2009

A coot pauses as it walks on the ice showing its outsized lobed feet. 5 January 2009

Robin puffed up on snow-covered lawn beside the Lake. 10 January 2009

The Marine Display

Plaice can bury themselves in a soft bottom with their bulbous eyes protuding and suck in worms and molluscs via their tubular mouth.
25 March 2009

Discovering there are seaweeds at Kew is a surprise to many people, but with so much of the Earth covered by sea, it is appropriate that Kew should have some marine plants on show. Tucked away in the basement of the Palm House is the Marine Display where six of the aquaria contain examples of British marine life.

This spread shows some of the life (which changes from time to time) to be seen in these tanks. The rocky shore aquarium features brown seaweeds – known as wracks – and the gaudy multicoloured ballan wrasse (*Labrus bergylta*) which lives in the subtidal zone amongst rocks and seaweeds. On hatching, all the fish are females and after some eight years they change into males. Young fish occur in the intertidal zone. This, the largest wrasse found around the British Isles, has very thick lips, bulbous eyes and variable – usually brown and green – markings. This tank has a condensed tidal cycle. Twice in every 24 hours, the water level drops over a period of 75 minutes and rises again.

The most obvious life in the rock pool tank are the snakelocks anemones (*Anemonia viridis*). Their sticky tentacles, which resemble writhing snakes, are used to trap fish and plankton. Constantly on the move are three-spined sticklebacks (*Gasterosteus aculeatus*); this marine form of the well known freshwater fish lives in shallow coastal waters – notably in estuaries – and also feeds on plankton. Both forms have two to four (usually three) distinct spines in front of the dorsal fin.

Most of the other inhabitants are not immediately obvious, because they are small and often lurk amongst the red and green seaweeds. Pause a while to see the estuarine shrimps and crabs emerge – especially at feeding time. Transparent live shrimps blend in with rock pool seaweeds, but become more obvious when they crawl out from their seaweed cover onto rocks or swim in open water.

The central circular tank contains commercially important fish. Bottom-living plaice (*Pleuronectes platessa*) are well adapted for burying themselves in soft bottoms, while the shoal of bass (*Dicentrarchus labrax*) swims above them.

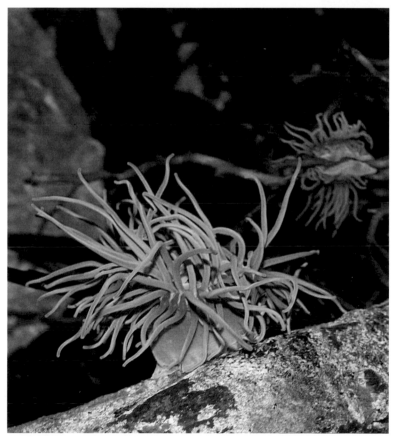

A snakelocks anemone most often reproduces asexually by simply splitting into two parts. 25 March 2009

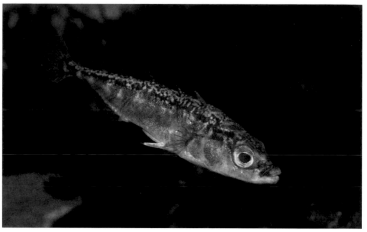

Eel grass (*Zostera marina*) is a flowering plant that forms extensive underwater meadows. Parts that become exposed at low tides are grazed by Brent geese (*Branta bernicla*) and wigeon (*Anas penelope*). Taken at Bembridge on the Isle of Wight

A three-spined stickleback which was bred in the rock pool tank. 21 March 2009

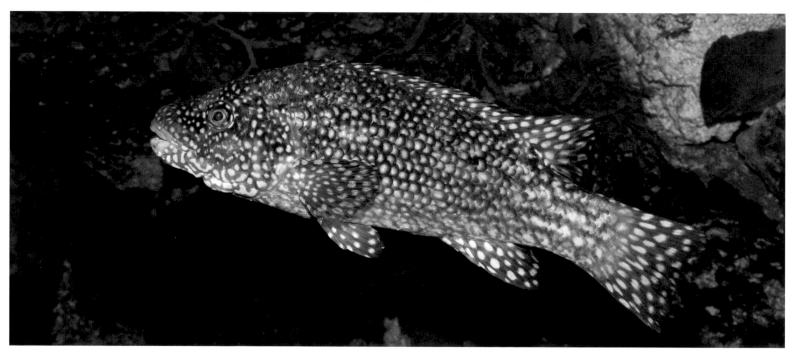

A ballan wrasse swims amongst rocks with egg wrack (*Ascophyllum nodosum*). 21 March 2009

Winter wildfowl

PHOTO TIP

Use reflections of colourful leaves – especially when they are sunlit – to add colour to drab water.

Wildfowl are present at Kew year round, but winter visitors swell the numbers of individuals as well as the species. The Sackler Crossing, which bisects the Lake, is a good place to watch the activities of large numbers of coots. As one dives to collect a beakful of green algae another homes in, waiting for it to resurface in the hope of gaining a free breakfast. To avoid the food being hijacked, the coot which has done the work makes a hasty retreat, so the whole area is alive with coots scurrying backwards and forwards through the water. After a spell of feeding, many coots climb out to congregate on land amongst the aerial roots of a swamp cypress to preen themselves before returning for another feeding session. If a dabchick happens to surface amongst the coots it beats a hasty retreat by diving and resurfacing beneath the Sackler Crossing. In winter, the attractive, rufous breeding plumage of this little grebe is replaced by a dirty brownish-grey plumage.

Mallards breed at Kew but come the winter they are joined by other ducks; tufted ducks (*Aythya fuligula*) forage mostly at night diving to feed on roots and aquatic life; whereas gadwall (*Anas strepera*) feed by dabbling. The male tufted duck is a classically understated monochromatic bird with a yellow eye set in a black head bearing a distinct head tuft of feathers, which gives rise to its name.

Canada geese make a very noisy appearance when a gaggle descends on the Lake, landing in quick succession with their feet lowered like undercarriages of planes coming in to land. The sheer size and numbers of these geese tend to make smaller wildfowl give way to them.

Black-headed gulls – the commonest inland gull – lose the dark chocolate colour on their heads in winter, but retain the distinctive red on their legs and bill. They can be seen flying up and down the Lake, sometimes landing on the water in the hope of stealing food from other birds. They also feed on live insects, worms and small fish as well as on carrion and waste scraps.

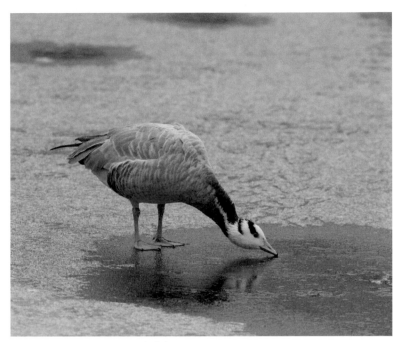

A bar-headed goose attempts to drink from the frozen Palm House Pond. 7 January 2009

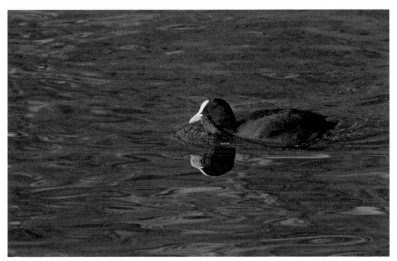

A coot surfaces with a beakful of green algae in water reflecting the autumnal colours of a Mexican cypress (*Taxodium mucronatum*). 29 December 2008

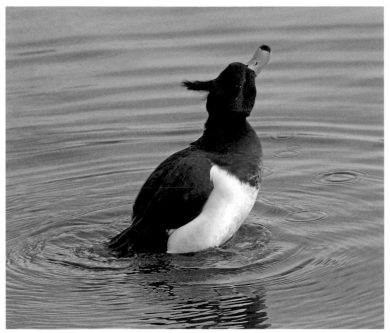

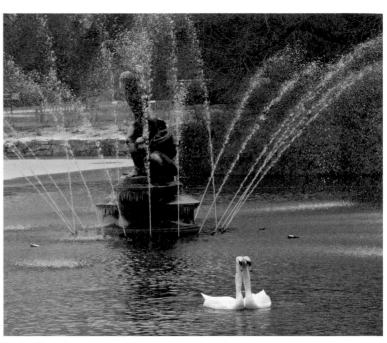

Rising out of the water, a male tufted duck shakes
surplus water off his head. 29 December 2008

A pair of mute swans court on the
Palm House Pond. 5 January 2009

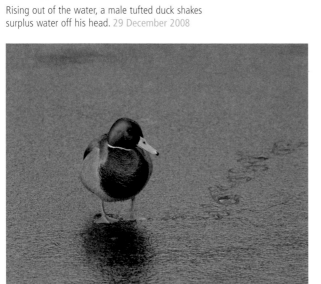

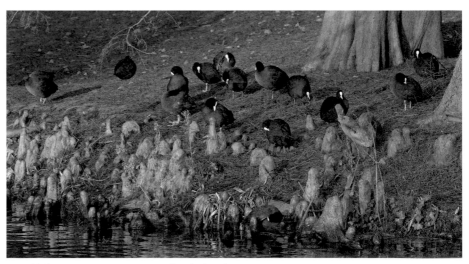

Low-angled winter sun highlights the iridescent feathers and orange
feet of a mallard drake standing on ice. 26 December 2008

Assembled amongst swamp cypress roots beside the Lake,
a covert of coots preen themselves. 29 December 2008

Index

BOLD numbers refer to image captions. Both scientific and common names are given in the text at the first mention of a plant or animal, subsequently only the common name is used.

Photographic notes

Every day at Kew is a voyage of discovery for wildlife sightings. Some animals will have their favourite places to feed. Many woodland birds are attracted to full feeders in the Conservation Area – regardless of the time of day. However, birds that feed on the lawns are more likely to be seen early and late in the day. Both the Lake and the Palm House Pond are rewarding places to see birds washing, feeding or defending their territory.

Several wildlife shots did not fit neatly into any of the topics, so are included here. Amongst the most surprising animals to be seen at Kew, must surely be the Chinese water dragons (*Physignathus cocincinus*) that roam freely in the Wet Tropics section of the Princess of Wales Conservatory. These, too, have their favourite spots on the water lily pool or on the grid walkway where heat rises.

When photographing any animal, the aim should be to get at least the eyes and head in focus in a head-on shot, whereas if the camera back is parallel to the side view of the body, it should be possible to get it all sharply in focus.

Seeing a peacock displaying and dancing to a peahen is always a thrilling sight and with several pairs of peafowl at Kew the shrill calls of the males are often heard. Once I found a peacock displaying to a peahen on a bench. When she remained unresponsive, he wandered off to feed. She then jumped off the bench and to my amazement began to erect her small brown tail, mimicking a peacock. Her display was a pallid imitation of the real thing and certainly did nothing to impress a passing moorhen. Apparently, a peahen will display when her chicks are threatened or to ward off other females. Quite what motivated this one to display is a mystery.

This is an example of how it pays to keep your camera easily accessible; unlike the time I decided not to take my 500 mm lens on a day I was teaching at Kew. From the first floor of the building that overlooks the Palm House Pond, we witnessed a cormorant rise with a huge eel and struggle for some time in an attempt to swallow it.

Cherry blossom is always a magnet to photographers. Yet it is trees with single, less showy flowers that attract insect visitors. On the same spring morning, a robin was singing its heart out atop a willow-leaved pear (*Pyrus salicifolia* 'Pendula') beside the cherries; whilst distinctive bee flies (*Bombylius major*) were hovering to forage on the flowers.

On a single day, it is impossible to cover the whole of Kew so inevitably there is an element of luck in being in the right place at the right time.

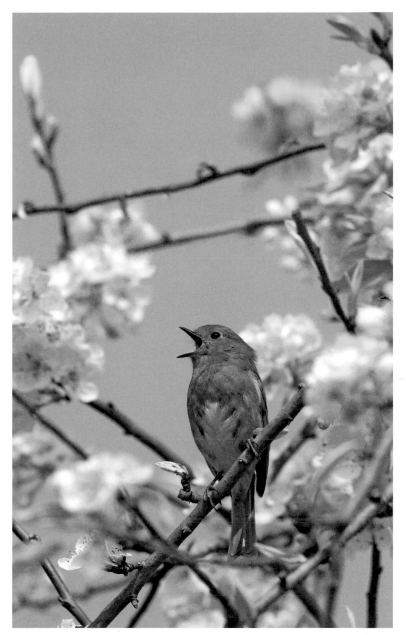

A robin singing in a willow-leaved pear tree within its territory was captured with a long telephoto lens. 16 April 2009

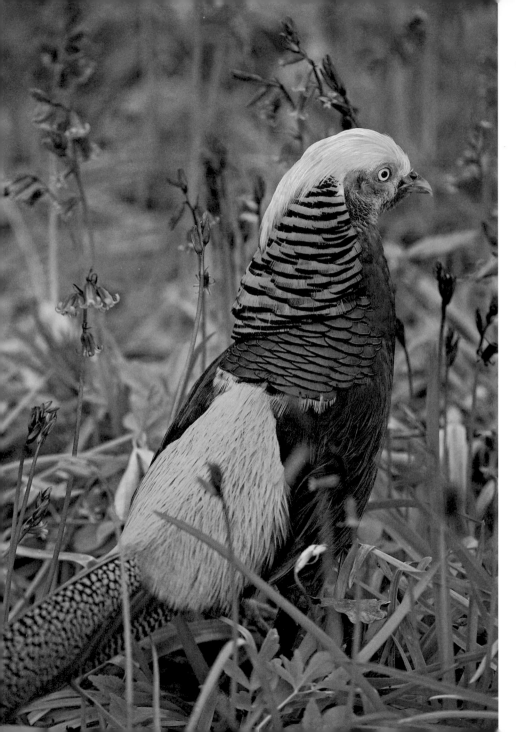

CONTENTS

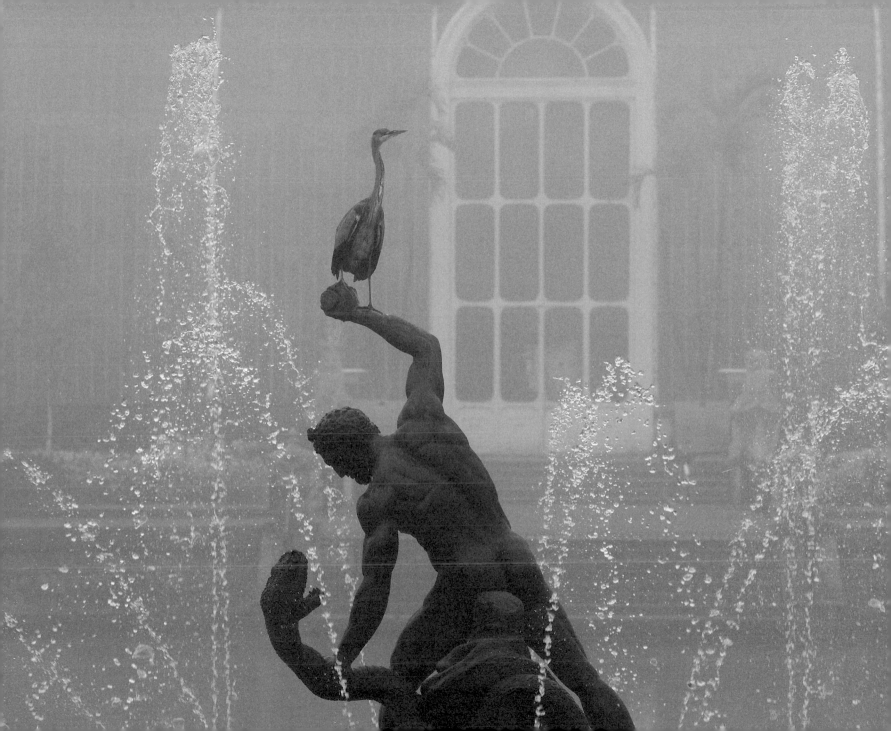

PLANTS PEOPLE
POSSIBILITIES

Many people helped me in the production of this book. I owe a great debt to Sandra Bell, who at the onset generously passed on her wildlife observations made over many years at Kew, and to other people who recorded notable sightings on the Kew website. As the year progressed, many people who work at Kew kindly alerted me of sightings I might have missed, since it was impossible to cover the whole of the Gardens in any one visit. Lydia White was quite brilliant at answering any query I thrust upon her. The UK Phenology Network (started in 1998) kindly helped with information about seasonal observations. I should especially like to thank Lucy Simpson who not only helped with the research, but also proofread much of the copy. Kate Carter also helped with proofreading and Ed Pugh assisted in preparing the digital images.

First published in 2009 by
Royal Botanic Gardens, Kew
Richmond, Surrey, TW9 3AB, UK
www.kew.org

ISBN 978 1 84246 402 1

British Library Cataloguing in Publication Data
A catalogue record for this book is available from the British Library.

Front cover illustration: © Heather Angel

Production editor: Michelle Payne
Design, typesetting and page layout by Nicola Thompson at Culver Design

Printed by Firmengruppe APPL, aprinta druck, Wemding, Germany

For information or to purchase all Kew titles please visit
www.kewbooks.com or email publishing@kew.org

All proceeds go to support Kew's work in saving the world's plants for life.

The paper used in this book contains wood from well-managed forests, certified in accordance with the strict environmental, social and economic standards of the Forest Stewardship Council (FSC).

Heather Angel's
WILD KEW

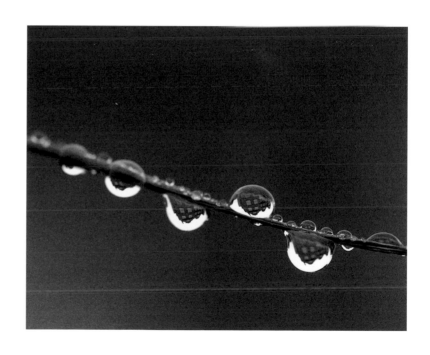